HAUNTED EASTERN SHORE

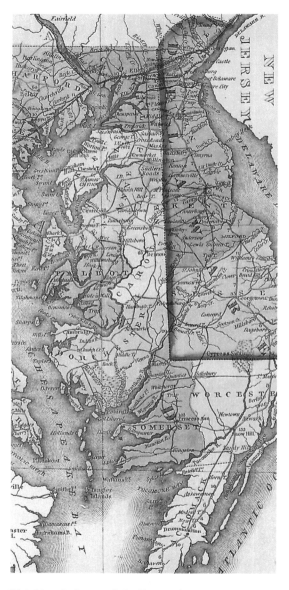

This historical map of the Eastern Shore shows Cecil, Kent, Queen Anne's, Caroline, Talbot, Dorchester, Worcester and Somerset Counties. Wicomico County (not shown here) was carved out of Worcester and Somerset Counties in 1867. *Courtesy of the Nabb Research Center, Salisbury University.*

HAUNTED EASTERN SHORE

GHOSTLY TALES FROM EAST OF THE CHESAPEAKE

MINDIE BURGOYNE

Haunted America

Published by Haunted America
A Division of The History Press
Charleston, SC 29403
www.historypress.net

First published 2009
Second printing 2009
Third printing 2010
Fourth printing 2011
Fifth printing 2012

Manufactured in the United States

ISBN 978.1.59629.720.3

Library of Congress Cataloging-in-Publication Data

Burgoyne, Mindie.
Haunted Eastern Shore : ghostly tales from east of the Chesapeake / Mindie
Burgoyne.
p. cm.
Includes bibliographical references and index.
ISBN 978-1-59629-720-3 (alk. paper)
1. Ghosts--Eastern Shore (Md. and Va.) 2. Haunted places--Eastern Shore (Md.
and Va.) I. Title.
BF1472.U6B865 2009
133.109752'1--dc22
2009030606

To J.O.K. Walsh and Natalie Chabot—both lovers of history, both promoters of Eastern Shore heritage, but more importantly, both good people and dear friends who can tell a good story and always make me laugh.

CONTENTS

CONTENTS

ACKNOWLEDGEMENTS

When compiling a work that includes elements of all nine Maryland counties on the Eastern Shore, various resources are required. I am forever in debt to librarians, historians, volunteers and people who simply open doors to information solely in the interest of revealing more about Eastern Shore heritage. All of the individuals who assisted me are too numerous to mention here, but I will highlight several whose help was invaluable.

I couldn't have completed this project without the assistance of Dr. Ray Thompson, Matt Heim and the staff and volunteers of the Nabb Research Center at Salisbury University. I used a number of files from the Folklore Collection that is housed at the Nabb Center. Over thirty years ago, SU students studying folklore were sent out all over the Eastern Shore and other parts of Maryland to collect information about traditions, farm practices, food preparation, home life, local legends, superstitions and anything else related to folk life. I scanned thousands of pages of folklore testimony gathered by these students, and the assistance and helpful cooperation from Matt and the Nabb Center staff helped me identify and select the best resources from the collection. Dr. Ray Thompson's leadership and direction have not only sparked passion and interest in students of history, but they have also been crucial assets to Eastern Shore

historians, genealogists and heritage-area specialists that will live well past his lifetime. His impact on our community and state cannot be measured.

Author and historian Jerry Keiser, now director of the Kent County Library, gave me some valuable information when I was struggling to extract photo images and content from private collections and historical societies. Jerry said to always trust your library for resources because its intent is to make information public. He said that libraries, by their very design, are positioned to help identify, provide and interpret information to the general public. He added that I should encourage any persons considering donating historical documents or photograph collections to give them to their local libraries—this way, those items will always be ready for public access without an exorbitant price.

The libraries and staff that were particularly helpful in this project were the Talbot County Free Library and volunteer Dave Ireland from its Maryland Room; the Denton branch of the Caroline County Library; the Chestertown branch of the Kent County Library; the Cambridge branch of the Dorchester Library and its director, Jean Del Sordo; the Princess Anne branch of the Somerset County Library; and the Snow Hill branch of the Worcester County Library.

The Cecil County Historical Society, specifically Paula Newton and Mike Dixon, gave enormous support in helping me find resources, scanning photos and providing documents. This group is the most cooperative and helpful historical society I have worked with in the state of Maryland. It has excellent resources and will go the extra mile to assist with research. Additionally, Marji Matyniak of the Old Bohemia Historical Society was extraordinarily helpful with information on the history of Old Bohemia.

In Kent County, Bernadette Van Pelt, Mark Mumford, Jerry Keiser, Dale Nicholson of St. Paul's Cemetery, Sandy Hines from the Kitty Knight House and Sue Thompson, genealogist for the Cosdens of Kent County, all contributed invaluable assistance. In

Queen Anne's County, I thank Faith Elliott-Rossing, Mrs. Marty Willis of Bloomingdale and Alan Michaels of the Kent Manor Inn. I offer special thanks to J.O.K. Walsh, Carolyn Spicher, Kathy Mackel and the Caroline County Historical Society. Also, thanks to Terry Fearins, Beth Brewster, Mary Ann Walsh of Willson's Chance, John Wilson of Athol and Sonny Callahan, who provided the rare photo image of Wish Sheppard. I am also indebted to Debbi Dodson and Nina Wahl from the Talbot County Tourism office; Patti Hambleton and Bob Shanahan, who shared information about Talbot sites; and James Dawson of Unicorn Books for his historical knowledge of Trappe and for operating the best rare and used book store on the Eastern Shore. Thanks to Marc Bramble, Paul Meyers, Hubert Wright, Natalie Chabot, Mary Calloway and Amanda Fenstermaker, who offered insight and information regarding sites in Dorchester. Also, thanks to Cynthia Freeman in Crisfield for sharing information on several haunted houses there.

I am extremely thankful to Margery Cyr, the director of the Dover Public Library in Dover, Delaware. Margery allowed me to privately view and photograph the skull of Patty Cannon and the documentation details of the artifact's provenance—another example of a library opening its doors to history and information.

Thanks to my editor at The History Press, Hannah Cassilly, who was patient and helpful, especially when I had my little nervous breakdown. And I offer enormous thanks to my family and friends who were ignored and abandoned while I devoted months of evenings and weekends to writing this book. I send my deepest appreciation to my husband, friend and soul mate—Dan Burgoyne. Dan made meals, cared for the animals, managed the household, read and edited manuscript drafts, encouraged me and built a solid system of support around my need for time to write. His help, without a doubt, had the biggest impact, and without it, I couldn't have completed the project.

One final note to you, the reader: My research for this book was gained not only from other books but also from numerous

newspaper articles, pamphlets and oral testimony given to the university folklorists. Parts of these tales and ghostly stories may be inaccurate because much of the information I gained was shaped by the perspectives of the informants. I claim only to have relayed the information I gathered as honestly as I could to shape the stories. Additionally, all uncredited photographs used in this book are the property of the author.

INTRODUCTION

After the last ice age, the Susquehanna River, with its headwaters in western New York, swelled and surged. It moved south and found its way to the Atlantic Ocean. In that process, the Susquehanna drowned a valley that was 195 miles long. This created the most studied estuary in the world and the largest in the United States: the Chesapeake Bay. It also divided the land, creating a peninsula some 200 miles long that is barely joined to the mainland. Today, this peninsula is known as Delmarva because it comprises three states: Delaware, Maryland and Virginia. It is also known as the Eastern Shore, as it is the land east of the Chesapeake.

Maryland's Eastern Shore is a world apart from the rest of the state. Connected in two places to the mainland—one connection being a small shred of Cecil County and the second a five-lane hyphen known as the "Bay Bridge"—the Eastern Shore accounts for one-third of Maryland's land mass yet contains only one-tenth of her people. The landscape on "the Shore," as it is called by locals, has little in common with its sister landscape to the west. Dense populations, cosmopolitan neighborhoods and the hubs of commerce like Baltimore crowd the mainland. The Eastern Shore has no big cities, only small historic towns, rolling farmland and

thousands of miles of shoreline. Residents and visitors alike feel the difference instantly as soon as their cars leave the Bay Bridge and land on the shores of Queen Anne's County. The pace slows. The land spreads out in front of you. The sky gets bigger, and tidal water is never very far away.

This peninsula is the largest contiguous piece of agricultural land between Maine and Florida. Agriculture has been the mainstay of the economy since the seventeenth century, starting first with tobacco, followed by seafood, fruits, vegetables and, most recently, chicken. It was agriculture that generated the wealth and built the small towns on the Shore. But it was the Chesapeake Bay and the chasm it created dividing the peninsula from the mainland that has kept development to a minimum.

Oh, the beauty birthed from the marriage consummating farmland and the tides—this is the Eastern Shore charism! The bones of the old plantations still creep up through the landscape, some still supporting the historic homes that have stood watch through social changes. Even the marshes, the swamps and the winding waterways have been left largely untouched, and the phantom spirits of those long gone are comfortable to linger here.

The wide-open spaces and expansive vistas, uncluttered by modern development, have left room for the ghosts of the past to wander. There are still places where spirits feel at home in the land where they walked, laughed, suffered, loved and died. Some of the souls lived as heroes and some as villains; others are unremembered or nameless; and some are known only by their quirky methods of reaching into the living world. Some spirits are unrestful and some are at peace, but their presence is felt by those willing to listen or look for them. Here you will find some of their stories, and perhaps you will seek out some of these haunts on your own. The spirits of government leaders, military men, movie stars, pirates and murderers will be mentioned in this book. Tales of George Washington, Tench Tilghman and the murderous Patty Cannon will be recounted, some with actual oral

commentary taken from citizens long gone who told their stories before they joined the very ghosts they chronicled in the world of the dead. As I take you through the nine counties of the Eastern Shore—Cecil, Kent, Queen Anne's, Talbot, Caroline, Dorchester, Wicomico, Worcester and Somerset—I will share the stories I have uncovered through research gathered from over fifty books, scores of personal interviews and thousands of pages of transcribed oral commentary. In addition, I will add my own commentary in some places, recounting a few spooky experiences I had when I visited these sites. And, hopefully, I will weave for you, the reader, a vivid account of past and present spiritual phenomena, giving you a more personal introduction to the ghosts that haunt houses, swamps, bridges, plantations, forests and the wide-open spaces of Maryland's Eastern Shore.

HOLLY HALL

Elkton, Cecil County

The northernmost county on the Eastern Shore is also the only one joined to Maryland's mainland. Cecil County has high ground, rolling hills and endless agricultural land clipped and cut by tidal water. Elkton, formerly known as Head of Elk, is the central town. Holly Hall figures prominently in its history.

James Sewell, the builder of Holly Hall, was the descendant of Charles Calvert, Third Lord Baltimore. Sewell's wife, Anne Marie Rudulph, inherited land near Elkton from her father. It was on some of this farmland that the Sewells built Holly Hall about 1810. Shortly after, the town of Elkton sprang up, and James Sewell became a prominent member of both the local community and the American colonies. He served as brigadier major of the Maryland Militia from 1805 to 1841 and commanded the Second Battalion at Fort Defiance in 1813, preventing the British from reaching Elkton. Additionally, he served as clerk of the court in Elkton and was one of the founders of the Trinity Episcopal Church (1832).

We know that Mr. James Sewell was a member of the Whig party and that he entertained many visitors at Holly Hall, some of whom were quite prominent in political circles. Holly Hall became a symbol of the elite class in the Upper Shore region. It was considered a mansion in its day, designed in the Federal style with many extras and

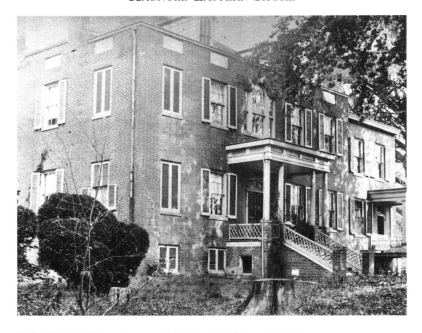

Holly Hall in Elkton. *Courtesy of the Historical Society of Cecil County.*

set amid beautifully landscaped gardens dotted with holly trees. It was the holly trees that compelled the owners to call the estate Holly Hall. Some of those holly trees and some of the old boxwoods still stand today in the shadow of the now vacant and derelict Holly Hall.

Everyone with whom I spoke in Elkton who knew about Holly Hall knew that it was haunted. The stories vary, but most refer to Mr. Sewell rejecting his son because of political differences and that same son cursing his father and the house with his dying breath. James Sewell built a brick burial vault into a slope west of Holly Hall some years after the house was finished. It had an iron door and a stone inscribed with "James A. Sewell's Family Vault—1838." Mr. Sewell died in 1842.

The following is an account of the haunting of Holly Hall as told by Mrs. Ralph Gray Davis to a Salisbury University folklore student on March 13, 1974:

In Elkton, the quiet little capital of Cecil County, there's an old family residence, now unattended...called Holly Hall, once the home of several of the most prominent families of the country but now fast...fast falling into decay. Now this was in a Baltimore newspaper dated 1894, so that's 79 years ago. The old house which still retains evidence of former grandeur, a stately appearance, is the subject of a peculiar superstition and many tales are told of the curious chains of happenings which gave rise to the belief in the unnatural influences supposed to hang over the mansion and those who lived in it.

Holly Hall was built about a quarter of a mile from the village that is now Elkton. It was built on big Elk Creek. The builder could not have selected a more gloomy site for a dwelling—in front of a dense wood (which you don't see now...it's all gone) that gradually sloped down to the marsh that edged the creek and shut out all of the view of the house on the water side. On the side towards the village, a bleak and barren area of marshland, inexpressibly dreary, stretched to the margin of the creek that separated it from the Head of Elk. The house was built on a slight rise of ground. At the back door, the ground descended suddenly into a dense, tangled swamp whose sinking vegetation concealed the hidden pools and treacherous mud upon which even a dog was afraid to walk. The only approach to the dwelling was over a narrow road which in a roundabout way made the village accessible by connecting with the country road which crossed the creek to the north east of Head of Elk.

The Sewell family was the first to live at Holly Hall, and there were rumors of stormy scenes between the father and a son—for there was at least one son and one daughter in the family. During a grave disagreement the father told his son that he (the son) should never enter the doors of Holly Hall again saying, "even if you die, your body shall not lay in a room of this house." The sister pleaded in vain for her father to recant, but he would not and the son left Holly Hall forever. The father then

pronounced, "He is no longer my son…not even a picture shall remain to gloom the walls of my house." There were several pictures of the young fellow in the house and with his own hands, the father destroyed them all. But the daughter concealed one picture from him. It was a portrait of her brother when he was at school at William and Mary College in Virginia. The young fellow had dressed himself in a military costume, much affected by young gallants in those days. His head was covered with a three corner hat, from which hung a sweeping ostrich plume. His shoulders were covered with a long Spanish cape descending to the waist and looped at the side to give a glimpse of a handle of a handsome sword and knee breeches, long shoes with toes turned up completed the rather fanciful costume.

This portrait, the loving sister concealed in the garret—a spot to which her father's aged stiffened limbs seldom attempted to climb. There the girl, faithful to the memory of her playmate and brother would go and gain many a stolen glance at the portrait. Through a fence, she received an occasional letter from the absent one. At last, a longer interval than usual elapsed between these communications. The sister grew alarmed and wrote along to an officer of her acquaintance in the company in the Continental Army. The answer almost set her wild with grief. Her brother was alive but in a hospital in Philadelphia, suffering from severe wounds and quick consumption which he had contracted from the awful exposure of the winter camp. Saying she was going to visit a friend in Philadelphia, the girl gained her father's consent and hurried to her brother's bedside. She found him wounded and helpless. His accommodations were meager as the suffering company could afford no better. The sister was determined to take her brother home, and was counting on forgiveness of her father when he saw the weak and shattered wreck of a young man—his son. She did not write to her father, afraid he would not understand the importance of the case. A carriage was hired and the son was placed on it and the homeward trip began and

lasted five days. The carriage entered the gloomy drive of Holly Hall and stopped at the front door. Two servants tenderly lifted the almost unconscious youth from the vehicle.

No sooner had the carriage stopped than the door was opened by the father. The unusual sound of wheels on the drive had brought him out to see who the invaders of his property were. A flood of light streamed from the open door to light the steps up from which the wounded boy was carried. His father recognized him and before an explanation was spoken he broke out in a torrent of curses. "Oh, father he's dying!" implored the distressed sister. "Let him die on the road, for I swore he should never gain entry into my house—living or dead" was the only reply she received. Knowing that it was useless to parlay with her father, the girl had her brother put back in the carriage and started back towards the house. He died the next morning with a curse upon his lips against the house which had refused him asylum.

After his death, strange stories were told about the house and its occupants. The young lady never left her room, the servants said. Her father grew more morose each day. One of his peculiar fantasies was the building of a vault that was not a stone's throw from the mansion. It was right across the road where a small hill was dug out. In the vault built of stone and cement, the earth was filled in again and the gloomy place was ready for its solemn departures. The first to find place in it was the old gentleman. Shortly afterwards his daughter followed. The mansion was unoccupied for many years. Then one of the most prominent families in the country—the Barrols—moved into it. While they lived there, their family affairs were the talk of the neighborhood. They quarreled among themselves—husband with wife, sister with brother. They were wealthy.

By unfortunate speculation, they lost their horses and their cattle wasted with a mysterious disease. The place is cursed they said. "We will leave." Before they did, two of the family slept in the vault. Well the key and right to the vault went with the

house and land. When they did leave, the family was completely wrecked and torn with quarrels. The house was again left to rats and owls for eight or ten years. Another family moved in—a husband, wife, and two children. The wife, a brilliant, beautiful woman was fond of gaiety and social life and the house was filled with young people. One day, the servant was sent up to the garret. Hardly had she been absent a minute before a terrific scream resounded through the house. Several young men rushed up the stairs and found the girl unconscious at the foot of the garret steps. When she recovered, she told them that as she reached the head of the stairs, she met a young man dressed in a three-cornered hat, knee pants, buckled shoes with a long cape muffled around his face. Thinking it was one of the merry young men masquerading, she stepped aside to let him pass. He stepped up to her and with a gesture, let fall the cape from his face. It was the face of a dead man, drawn and white. She screamed and fell to the floor.

The garret was ransacked. Covered over with some loose boards, they found the portrait of the young officer. It had lain there many years. Strange to say, it had been undisturbed by rats or mice. It was placed against the wall and left in the garret and the searchers returned downstairs, impressed with the affair.

Another night, the young lady walking alone in the shrubbery screamed and rushed into the house. She said she had met the counterpart of the portrait and had seen his ghostly face. These tales grew so frequent that it was hard to find servants willing to work for the family. Then the master and mistress of the house fought over the attention of a young man and the latter. The affair reached its climax when the two men met on the staircase. The husband cowhided the other. The combat aroused by the occurrence caused the family to leave the county and the house was left vacant again after being occupied for five years.

It was rented again as a laborers boarding house by a man named Levit. Then the ghost stories began again. Men boarding

at the house swore they met the spirit about the house and grounds. He was always dressed the same…always uncovered his face with the same gesture described before. At nights, sobs and groans issued from the vault and the iron door was sounded as though struck heavy blows from the inside. Reports grew so frequent that the noises coming from the vault were investigated. The vault was opened for the first time in ten years. The coffins were found in an excellent preservation but frequent high tides from the river had entered the vault and floated the caskets from their original resting places. The caskets were rearranged and the door locked. Shortly afterwards it was again opened to receive the body of a descendant of the original owners. The ghost of the portrait made its appearance so frequent that no boarders would stay in the house. The people running it lost money and it was left vacant again.

The Jeffers moved in and the curse that had rested on the place increased malignant. The family consisted of husband, wife, and the husband's sister. A girl about eighteen years old, standing on the porch watching a thunderstorm that had seemingly passed over was killed by a bolt of lightning—a bolt of lightning in a perfectly clear sky. Two months afterwards, horses were killed of the same destroyer while huddled together in a field during a storm. The entire family and several friends almost died from the effects of drinking milk from their own cows, which contained some mysterious poison that an analysis could not discover.

Sickness played a heavy hand on the entire family and at last—dislocated and broken—they left the place. Through all this, the portrait stood undisturbed in the garret. No one felt that they had a right to destroy it. The house is vacant at present and if it was to be rented free, no one would live in it. The vicinity is shunned by everyone. The high tides enter the vault and the coffins float about in the water. The boxwood around the mansion have grown large and ragged. They were once the finest boxwood around this part of the country. The gray exterior of

the house adds to the air of general desolation, and like a dark cast, seems to hover over the entire place. The house is tended by no living creature save bats and owls. Yet there is one other tenant—the portrait in the garret—fast fading with age. It holds sway over the echoing rooms.

The property was lately sold at auction and was purchased by Colonel William Singerly, proprietor of the Record. It is not likely that its present owner will ever live in the old mansion. The house and its grounds are too gloomy for the Philadelphian, who would rather spend the night in his pretty Queen Anne's cottage in the town than in the bleak house whose floors resound to feet that make no imprint…imprint in the dirt that covers them and whose halls are ever silent save for the noise of rats crawling in the plaster, scampering away from the unreal figure that descends from the haunted portrait.

Additional accounts of the haunting of Holly Hall address the sister of the young man in the portrait who cursed the house with his dying breath due to his father's rejection. It is told that the young woman never forgave her father and retired to an upper room in the house, refusing to speak to anyone, so consumed was she by grief. Her only companion and friend was her little dog, which stayed with her faithfully. The young girl's father died and was buried in the vault on the property. Shortly after, she herself collapsed, slipped into a coma and died. She was buried in the vault with her father. The night after the burial, servants saw the little dog yapping and barking outside the vault and trying to dig. The dog was inconsolable and would not leave the vault or stop his erratic behavior. The next morning, the servants found the dog exhausted, lying on his side by the vault with his little paws raw and bleeding from digging so hard. Curious, the caretaker had the vault opened, and inside they found the body of the young woman, who evidently had not been dead when placed in her coffin and sealed in the vault. She had climbed out of the coffin and was found dead

at the vault door, with her fingernails scraped off from trying to dig herself out. There are both verbal and written accounts of people seeing the young girl with her dog roaming the grounds of Holly Hall on moonlit nights.

Whether these accounts are true, partially true or untrue, Holly Hall has been known to the locals in the Elkton area as a haunted property for over one hundred years. There are verbal accounts given as recently as two years ago of phantom images appearing on the lawn in the evening, mysterious crying sounds coming from the property and images appearing in the upstairs windows. Haunted or not, the place is a site where many mysterious happenings have been witnessed over the years.

Today, Holly Hall still stands derelict, abandoned to the forces of nature and the encroachment of modern times. Vandals have broken almost every pane of exposed glass. There is a huge padlock on the front door similar to ones seen on old jail cell doors. Most of the windows are boarded up with plywood. The sprawl of development, with strip malls, concrete and asphalt, intrudes on the once peaceful home that stood on the undeveloped fringes of a small Maryland village. Noise from traffic where two busy state highways intersect overlays the already crowded surroundings of present-day Holly Hall. The entry to its once regal, tree-lined drive is flanked by a shopping center marquee listing offices and stores and a commercial "Space for Lease or Rent" sign. It looks as though the house was carved up into apartments, evidenced by several electric meters attached to the rear façade. The boxwoods are overgrown but are still present at the edge of the property. I noticed an overcoat, hat and several food rations stashed under the boxwoods when I visited Holly Hall while researching this book. It seemed as if someone was living there.

There is one constant on the property besides the house itself: the trees that loom over the front and rear lawns. Even some holly trees from whence the property took its name still stand after several hundred years, stately and unmoved by their encroaching

surroundings. It is comforting to recall that these trees were here when Holly Hall was built and when Mr. Sewell allegedly rejected his son. They were here when the forlorn sister tried to claw her way out of her tomb. They were present when all of the subsequent families who lived here bore the burden of living in a house alleged to be cursed. They are the silent witnesses of Holly Hall's seen and unseen past.

OLD BOHEMIA CHURCH

Warwick, Cecil County

In 1634, when two hundred colonists landed in Southern Maryland, a Jesuit priest named Father Andrew White was part of the entourage. He said Mass the day they landed and named the landing spot St. Clement's Island. As the colonies grew, Catholics were severely persecuted. In 1704, all Catholic churches were closed by authorities then in power. Yet, in that same year, Father Hunter, who was superior of the mission in Southern Maryland, chose Father Thomas Mansel—a Jesuit—to travel north to Cecil County to found a mission and build a school to educate young men for priesthood.

At that time, Cecil County was a wilderness, far away from clusters of population. It would be easier to operate a Catholic mission when it was out of sight of prying eyes. Father Mansel sailed up the Chesapeake and up the Bohemia and obtained land between two branches of the Bohemia River. There he founded his mission and named the tract of land St. Xavier. On a high piece of ground, he built a chapel and a log cabin. He named the chapel St. Francis Xavier after the most famous Jesuit missionary. In 1774, Father Thomas Pulton founded a Jesuit Academy on the property for educating young men. John Carroll attended the academy about 1747 and went on to found Georgetown University. He later became the bishop of the

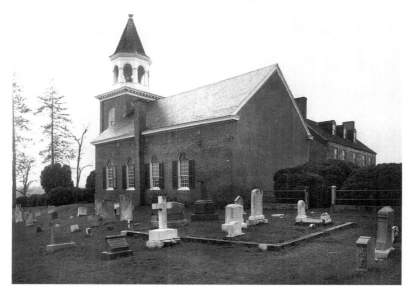

Old Bohemia Church. *Courtesy of the Historical Society of Cecil County.*

first established diocese in the colonies—Baltimore—making him the first American Catholic bishop.

Also attending the academy was John Carroll's cousin, Charles Carroll of Carrollton. Charles was the only Catholic signer of the Declaration of Independence, and he outlived all of the other signers, dying at the age of ninety-five. Both John and Charles Carroll were chosen by the First Continental Congress in 1776 to accompany Benjamin Franklin and Samuel Chase on a mission to Canada to obtain aid for the colonies. The academy (now gone) was located just in front of where the rectory building now stands. Its foundations can still be seen.

The mission grew to be a large plantation of twelve hundred acres and became known as Old Bohemia. In 1797, when there was finally some relief from religious persecution, the church was built. It still stands, and behind it, under a grove of very old boxwoods, lie the remains of ten pioneer Catholic priests who were instrumental

in spreading the faith in the colonies. Buried in cemetery are heroes from every American war, as well as the famous Kitty Knight of Kent County who stood up to the British fleet and convinced them to stop their plundering and leave her town. Miss Knight attended Mass at St. Francis Xavier's. She is buried just outside the south wall of the church.

By 1825, the academy had fallen into disrepair, and the bricks (which were baked at Old Bohemia), as well as the wood, moldings and everything else that could be salvaged, were reused to build the rectory, which is currently attached to the church building through the sacristy. The Diocese of Wilmington, which encompassed all of Delaware and the Eastern Shore of Maryland and Virginia, was established in 1868. Old Bohemia, being the oldest church in the new diocese, was considered, and still is considered, the "Mother Church" of the Diocese of Wilmington. By 1898, the Jesuits relinquished ownership of the mission to the diocese, ending 194 years of Jesuit missionary work. In 1931, the bishop sold the farm to a local farmer, retaining only the church, rectory and cemetery on just under four acres. All fell into disrepair, but in 1953, the Old Bohemia Historical Society was formed and restoration and preservation efforts were begun. These efforts continue under the society's care.

Mrs. Mary Devine Dunn worked in St. Francis Xavier's Church at Old Bohemia, helping out in various ways. In 1974, she gave the following oral testimony to a Salisbury University student who was collecting information for a folklore class. Mrs. Dunn's testimony deals with ghosts and apparitions appearing in the rectory and church. The testimony has been edited for better readability.

Father Rimlinger [who served as pastor in 1956] *had Father Charles Crowley* [who served as pastor in 1904–29] *down one night for dinner and heard an interesting story. Father Rimlinger told me that Father Crowley, who was the third non-Jesuit pastor at St. Francis Xavier, was saying Mass one day and there were three or four people in attendance. He heard a*

commotion behind him, and all the people got out of their seats and went up on the altar with him. They looked towards the sacristy door where they saw Father Daniel Haugh [died in 1902]. *He was standing there with his cassock at the sacristy door coming right into the church. Father Crowley said he saw Father Haugh two other times. But at this particular time, about five people saw Father Haugh—really saw him standing there. He'd been dead quite a few years then…Of course I didn't see Father Haugh appear, but he was the last Jesuit pastor there. Of course, I believe that Father Crowley certainly told Father Rimlinger. He had no point in telling that if it were not true…*

Getting back to that Sacristy door…[The sacristy was the building connecting the church and the rectory where the priests lived. There was an entry door to the church, as well as one going into the rectory.] *Well, it was summer, you see, and I have a little brass bell. I had my son-in-law make a stand for it and I put it right in at the door from the sacristy coming into the church, so when people come through the door they ring bell—just as they always did in other churches when the priest comes from the sacristy into the church. I had an old white cord that I put on the bell so you could pull it and make the little bell ring. I used to take the cord off and wash it maybe twice in the season. I was standing about as far away as from me to you and looking at Ann Ludwig who was sitting in the church. I said to her, "You know I don't think I'm going to take that cord off today. I'll skip another Sunday. It doesn't seem to be soiled." Just as I said that the little bell rang. I said, "Ann, did you hear that?" She said, "Did you ring it?" I said, "You know I'm not even near the thing." The bell didn't move but it did ring—and it was right by the door that Father Haugh was supposed to have been seen in. So, you never know how long people have to stay in Purgatory.*

During my research on Old Bohemia, I conducted interviews with people from the Old Bohemia Historical Society and those who have connections with the church. All agreed that there was a "presence" there. There were several accounts of people hearing doors open, footsteps walking the halls and boots clomping up and down the stairs in the old priest living quarters. One person told of a book mysteriously appearing in one of the priest's bedrooms and eyeglasses relocating themselves. Workers hired to do renovations complained about being able to hear voices, especially in the sacristy, but no one was there. Another volunteer stated that she was in the church alone. She knew she was the only one at the isolated property, but she heard voices in the sacristy. She approached the closed door and could clearly hear people behind the door whispering. She opened the door and no one was there.

All agree, however, that the presence is peaceful and benevolent. Old Bohemia is a happy place. Standing at the south side of the church looking out across the cemetery, one gets a splendid view of the Upper Shore landscape. The property is surrounded by rolling farmland. I stood there at dusk when I visited, and I had an overwhelming sense of being able to feel all that had happened there in a few short moments. There is deep faith and peace at Old Bohemia.

Above the entrance to the St. Francis Xavier Church at Old Bohemia the following words are inscribed:

> *Indeed the Lord is in this place and I knew it not…*
> *This is no other but the house of God and the gate of heaven.*
> —*Gen. 28 16:17*

MITCHELL HOUSE

Elkton, Cecil County

The Mitchell House at 131 East Main Street in Elkton was built by Dr. Abraham Mitchell about 1769. Dr. Mitchell was a physician who came to Elkton from Lancaster County, Pennsylvania, and settled his family into a home outside of the town center. He then built this side-passage town house in town, probably as an office. Dr. Mitchell was a Patriot and was devoted to the cause of independence during the Revolutionary War. He converted this town house into a temporary hospital for wounded soldiers and tended to them there with his professional skills as a doctor. A chapel in Valley Forge is dedicated to Dr. Mitchell for his benevolent care of Continental army soldiers in his "hospital-home" during the Revolutionary War.

In March 1974, Mrs. Betty Murphy dictated testimony to a Salisbury University student who was studying folklore. Mrs. Murphy lived in the Mitchell House as a child, and she discussed unusual events and paranormal happenings that occurred there during her childhood. The written transcription of this testimony is on file at the Nabb Center at Salisbury University. Portions of it appear below.

The house was used as a hospital during the Revolutionary War—probably a temporary place—maybe an emergency

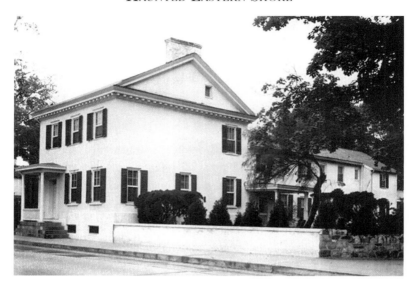

The Mitchell House in Elkton. *Courtesy of the Historical Society of Cecil County.*

place…The first thing that happened…my mother was alone in the house around three o'clock in the afternoon and she heard this unearthly laughter. She went all over the place looking for it. She went out on the street—everywhere—and couldn't find anybody or anything that would be making this sound. It was just real like you'd hear in a ghost movie that "ha ha ha ha ha" laugh. She didn't say anything for a week or so. She didn't want to scare us because we were children, but as we grew up, things just happened and you wondered what these things were.

We had a boxer dog. We had two different dogs and each of them would go to a certain corner and at different times. They would stand there and their hackle would go up and they would bark and back all the way across the room and just stand there and shake. I mean they weren't timid. They were mean. Once my brother and I were out. We came in around 11:30 pm. At about 11:00 pm, my parents heard the front door close with a bang. Now in the back of the house where the Judge Rollins has his

office—which is a good 90 feet away from the front door—they heard clonk, clonk, clonk, clonk…and they said, "My, they're home early tonight." The dog took off to greet us but backed clear from the front hall back to the back wing like this (gestures), backing and shaking. My father said, "All right now, what are you kids doing? Come out and tell me. Where are you?" He said he knew he heard that door close and the clump, clump, clump almost to where they were and that we were playing games. My mother said, "Were you in here earlier kidding us, you know?" I said, no, we weren't there. And my father, we always told him, "Now you know you hear that, Dad." He'd say, "Yes, well I think I did." They were a little upset that night.

Another time in the dining room…it was around 5:00 in the evening, we heard this horrible thud, thud, thud, thud just like someone was using a sledge hammer in the next room. Again the dog ran in and stood over where we thought the sound came from. I called the man who had an apartment directly over where the noise was and I said, "What are you doing?" "I'm not doing a thing, I'm watching television" he said. "Well, didn't you hear that horrible thump thump thump like a sledge hammer?" He said, "No, I didn't hear a thing." He had to have been sitting over the identical spot.

See when these things happen you're frightened at the time, but the second they're over, you're not scared anymore because they're gone. You have no feeling about this. Another time I woke up in the morning. It was around 6:00—gray, dreary and I had this kind of a chilly feeling and I thought, "Why am I awake?" because you have to shake me and hit me to wake me up. I sat up in bed and I looked at the clock at approximately 6:00…funniest feeling and the room got cold. This cold cold feeling overcame me. I thought, well I don't know what that is. I just cuddled up and put the covers like this (gestures covers over her head) and all of a sudden, I had this feeling like there was something…a thing above my head on the bed, so I grabbed like

that (gestures) and I looked with this eye and I looked with this eye (gestures) and each of my hands was grasping a hand. So, I said a prayer and it went. People have asked me, "What did the rest of it look like?" I said, "Well, if you think I turned around to see…you are crazy!" That was a little shaky but those hands were the only two things that I ever saw.

My mother had seen the man who used to come and stand by her bed quite often. She could see every so often, a man dressed in a frock coat and dark clothes. He would stand by her bed. She said particularly when she was sick. She had high blood pressure and she was in bed awhile and said she would think it was my father, until she looked to find he was either in another room or in bed. This would upset her a little bit, so she got so she slept downstairs. She wouldn't sleep upstairs, it got so bad.

A lady worked for us for about 15 years while we lived in the Mitchell House. About five years before we moved she came to my mother and said, "I don't work here if there's nobody in the house." My mother said, "Well, what's the matter?" and she said, "I don't like that woman who is always asking me questions." My mother said, "That woman?" The lady said, "Oh, I'll be ironing or something, and she'll just come up to me and say, 'Who lives here now' and 'What are their names' and I look again and she's gone. I don't like that kind of stuff and I will not stay here." She said, "When you leave, I leave." And that's how she worked. The minute any of us had to leave, she quit work for the day. We didn't know what she meant. We thought it was someone coming into the house and then all of a sudden, it dawned on us. We didn't say (laughs) anything to her because she was really frightened. When my father asked her, "How did the woman come and go? Did she come in the front door?" She said, "I didn't see her come in. I didn't see her leave. I don't like this kind of stuff."

The Rollin family moved into the house after we moved out. I guess they had lived there five years when my mother and I

stopped in to see them. They had never seen anything strange and thought this was all funny. They said to us, "Oh, come on up and we'll show you what we've done to the attic." I said, "No, I don't go up in the attic" (laughs) and then they said, "Why?" I said, "Oh, something will happen." Mr. Rollin said, "Nothing will happen." "Oh," I said, "about the time I put my foot on that top step, the lights will go off." He laughed and laughed and encouraged me to climb the stairs to the attic. So I put my foot on the top step, and the lights went out. Everybody traipsed down to the first floor landing and I stood on the second landing looking up. He went down to the basement to see if he could see what was wrong with the fuse box and I stood there for quite awhile and I thought, "Boy, I'm not going to stand here a minute longer in the dark." So I came down to the first floor and the lights went on and I yelled down to him, "The lights are on," and he said, "Well, what did you do?" I said, "Well, I came downstairs. What did you do? Didn't you put the fuse in the box?" He said, "I haven't even found the fuse box yet."

Mrs. Murphy's account of her family's experiences at the Mitchell House brings up an interesting paranormal conundrum. Do ghosts or spirits choose who can and can't see them, or do certain people have a special gift that allows them to see into the spirit world? Could both be true?

COSDEN MURDER FARM

Galena, Kent County

O n February 27, 1851, near the small village of Georgetown Crossroads (now Galena), four fiendish perpetrators invaded the Cosden home and brutally murdered four people and injured three in a "death-dealing orgy," according to the *Kent County News*. It was—and still is—the only mass murder in nearly four hundred years of Kent County history. The crime began early one Thursday evening as the Cosden family sat sipping tea after dinner; it ended within an hour with bodies strewn across the house and the property riddled with gunshots. The Cosden family was murdered, shot, stabbed, bludgeoned and burned. Two escaped the horror and ran for help. Four lived to recount the gory details.

At the time of the murders, the Cosden farmhouse and property were known as the Moody Farm. Robert Moody purchased the property and built a house on it in 1798. The dwelling was simple: a two-story, brick, farm-style structure built over a basement. Strangely enough, Robert Moody had the house built a quarter mile off the existing road. This was not the norm at the time; most houses were built close to the road for easy access. Additionally, he built the house with its doorways facing south, away from the road, leaving the main entrances visually obscured from neighbors and passersby. The house sat about one and a half miles east of Galena,

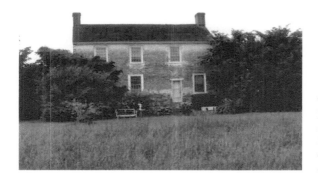

The Cosden
Murder House
(demolished in
2008). *Courtesy
of the Maryland
Historical Trust.*

just south of the Sassafras River. It was demolished in 2008, having fallen into grave disrepair.

William Cosden, a tenant farmer, was leasing the property from Mr. James Woodland, who had acquired the farm from the Moody family. In 1851, there were at least seven people in the Cosden household living in the two-bedroom farmhouse. They were Mr. William Cosden and his wife, Mary Ann (Webster) Cosden; their two children, Mary Katherine (age four) and a four-month-old infant son; Mr. Cosden's sister, Amanda Cosden (age seventeen); and Mrs. Cosden's sister and brother, Rebecca Webster (age seventeen) and Dickenson Webster (age fourteen). In addition, the Cosdens had an African American servant woman.

On that fated Thursday evening in February, the Cosden family was settling down after dinner. Mr. Cosden was drinking his tea facing the fireplace in the company of Mrs. Cosden and his sister, Amanda. The Cosdens' infant son was asleep in his cradle tucked under a table. Dickenson Webster, the servant woman and an African American teenage boy (perhaps the servant woman's son) were in the kitchen. Mrs. Cosden's sister, Rebecca, had been ill and was confined to bed upstairs in one of the two bedrooms. Mary Katherine, the Cosdens' four-year old daughter, was also upstairs, probably asleep in the other bedroom.

Somewhere between six and seven o'clock, four white men came onto the Cosden property with the intention of robbing what they thought was the Caleb Griffith house, where a farm sale had netted in excess of $3,000 the week before. The robbers suspected that the profits were still held in the house. The Griffith house was in Kent County, about two and a half miles from the Cosden home.

The carnage began when one of the robbers pointed his musket through a window and shot Mr. Cosden in the head. As soon as Mr. Cosden was shot, Dickenson and the African American boy fled to town to get help and escaped the murder rampage uninjured. The four perpetrators beat down the door, entered the house and shot Amanda Cosden, who was sitting at a table. Then one of them shot the servant woman in the face. Mrs. Cosden was also shot, but she was able to flee out the front door. The fiends hunted her down and stabbed her to death. It was later discovered that Amanda Cosden also had stab wounds. Upon hearing the ruckus downstairs, Rebecca Webster ran to a bedroom closet to hide. But four-year-old Mary Katherine came running into her room, frightened and screaming. Rebecca exited the closet to rescue Mary Katherine just as one of the assailants came into the room. The girls jumped onto the bed, and Rebecca pleaded for their lives, stating she had money in a trunk. The assailant promptly shot her and then emptied the trunk, obtaining $4.00 and an overcoat. He then shot at both girls, who were still on the bed. The fire from the gunshot set the quilt ablaze. The two wounded girls held each other on the burning bed.

At this time, Mr. Cosden was still alive. He had managed to crawl under the table, where his infant son still lay in his cradle. To quiet the child, he gently rocked the cradle. The assailants discovered Mr. Cosden was still alive and shot him again, stabbed him and then stomped on his face.

The alarm had been summoned by the young boys who had escaped the murderous rampage. The robbers evidently stole what they could and fled before help arrived. When neighbors entered the house, Mrs. Cosden and her sister were dead. Mr. Cosden was

still alive and able to talk. He was still under the table, rocking his son's cradle to quiet him. He stated before he died that he did not know his attackers. Rebecca and Mary Katherine were also still alive, though Rebecca died of her wounds two days later. Young Mary Katherine recovered, as did the servant woman. The infant son died three months after the murders. No one ever recorded the cause of death.

Within a week, arrests were made. One of the perpetrators, Stephen Shaw, turned state's evidence against the three men he claimed were the other assailants: Nicholas Murphy, Abraham Taylor and William Shelton. Stephen Shaw was not tried, but the three men he named were tried, convicted and hanged. All three clung to assertions that they were innocent right up to the final moments of execution. Abraham Taylor's last words were that his life had been sworn away by Stephen Shaw and that he was innocent. The cold atheist, William Shelton, who was named by Shaw as the murderer of Rebecca Webster and Amanda Cosden (as well as the shooter and abuser of four-year-old Mary Katherine Cosden), showed no remorse and made no public comment. Nicholas Murphy claimed that he was home in bed at the time of the murders. Murphy wept and exclaimed, "Murderers, now do your work; but, bear in mind that you do not hang murderers."

The gallows were placed on raised ground near the mill, about one mile from Chestertown. It was an elevated area with at least half-mile views in every direction. Newspapers reported that thousands attended the hangings on August 8, 1851. Troops were called in to maintain order. The convicted men were led to the gallows. Hoods were placed over their heads and the ropes put round their necks. As the floor gave way, Taylor and Shelton dropped and died quickly. But Murphy's rope broke, and though he fell twelve feet and his throat was mashed and lacerated, he did not die. As he rose with some assistance, he passed the hanging bodies of his dead consorts and exclaimed, "My God, two innocent men sacrificed." Murphy was re-escorted to the gallows and dropped again. Though the rope

and knots were secure, newspaper reports state that he took nearly eleven minutes to expire after being hanged the second time.

When a crime as sensational as the Cosden murders occurs, distortions of the truth surface naturally. Some newspapers—in particular, an article written by Bill Usilton for the *Kent County News* shortly after the murders—claimed that the murderers were African American. This is untrue. All four men charged, and even the additional men who were arrested on suspicion and later set free, were Caucasian. This has been proven by Cosden genealogist Sue Thompson with unwavering evidence. Various local accounts orally passed through generations claim that a bloodstain—more prominent when it rained—would appear on the front door of the Cosden house for years and years after the murder. Other claims have been made that blood on the floor could never be removed.

Since the Cosdens were killed, the property has changed hands numerous times, with six to eight subsequent families occupying the place. Some accounts of residents and visitors state that when on the Cosden Murder Farm, one got the feeling that he or she was "being watched." Other accounts, directly from occupants, refute those claims. Mrs. Thompson, the Cosden genealogist, told me that she had been in the house and photographed it. Bullet holes, some with musket balls intact, were still lodged in the mantle and over a doorway. Another relative gave oral testimony that he remembered bullet holes in the walls and a door riddled with bullet holes that was later removed.

There are a few interesting points associated with the Cosden property. One is that after the murders, the house and property were referred to as the "Cosden Murder Farm." This name stuck and even appeared on deeds associated with the property in subsequent years. It was perfectly natural for Kent County locals to refer to the property as the Cosden Murder Farm—just as they might say "the old Moody Farm." The last family who lived on the farm, having owned it for twenty-five years states, "In that whole time [we owned the farm] it was very hard to have things delivered there

with just giving people simple directions. You had to say the Cosden Murder Farm or they wouldn't know where to take supplies." This family sold the house on February 27, 2002, the 151st anniversary of the murders. It was the last time the house would be sold; the purchasing owners had it demolished in 2008.

Some forty years after the horrific crime, a relative of the murdered Cosdens, Thomas Cosden of Chestertown, served as a first mate on a schooner operated by Captain Leonard Tawes of Crisfield. In 1893, Cosden became ill, and Tawes had to put him in an island hospital in Antigua to recover. Weeks later, Tawes and his crew encountered a hurricane. The crew told Tawes that the old first mate—Cosden—helped them during the storm. But Tawes knew that Cosden was in the hospital at the time. The hospital where Tawes brought Cosden has a record of Cosden dying on the same day as he allegedly assisted the crew during the storm.

Another twist in the Cosden family chain is a distant relative who rose to fiendish fame in the twentieth century. William Earl Cosden Jr. was found not guilty by reason of insanity for the rape and murder of a Maryland girl in 1967. He was incarcerated for three to four years and then released. He went to Tumwater, Washington—near Seattle—to work in a truck stop owned by his father. He was later found guilty of the 1973 murder of Katherine Devine but not until 2002, when DNA evidence linked him to the crime. Up until then, Ms. Devine's murder had been attributed to serial killer Ted Bundy.

Mary Katherine Cosden, the four-year-old who survived the Cosden murder rampage, went to live with relatives who were suspected to be unkind to her. She was eventually relegated to a boarding school. She married and moved to Sioux City, Iowa, where she lived for sixty-four years before dying at the age of ninety. Nothing remains of the Cosden farmhouse and scene of the gruesome murders. The current owners told the Kent County zoning office that they intended to build a new home in the same location in which the farmhouse stood. For now, the site is vacant.

WHITE HOUSE FARM

Chestertown, Kent County

On the highest piece of ground in Kent County, Maryland, with expansive views of woodlands, pastures and a lake, sits an old French-style farmhouse. The house has occupied the same spot for nearly three hundred years and is one of the oldest surviving structures on the Eastern Shore. White House Farm lies just about four and a half miles north of Chestertown. It was built in 1721 by Daniel Perkins, a Quaker from Wales. Daniel was recorded as being a stone cutter, a millwright and a tavern owner, and he was no doubt an integral part of the eighteenth-century community in Kent County. In the unglazed brick on the north gable of the farmhouse, the numbers "1721" are carved. These numbers, etched by the builder, record the year the house was built.

Daniel Perkins was a relative of Isaac Perkins, the Revolutionary War hero known as the "Flaming Patriot." White House Farm held its place in Revolutionary War history. Its mill supplied grain for General George Washington's troops. General Washington visited the farm whenever he traveled up the north road—the same road that is known today as Route 213—running north through Chestertown and into Cecil County. The famed "father of our country" and America's first president was well known in the Upper Shore region. He served on the first board of governors at Washington College in Chestertown. Some believe that George Washington is still in the region—in spirit, that is—on White House Farm.

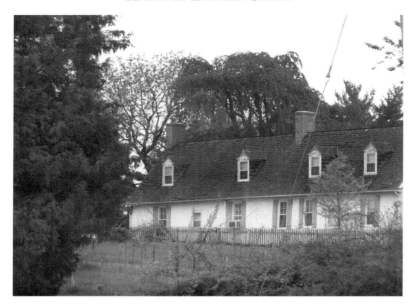

The White House Farm, near Chestertown in Kent County.

White House Farm remained in the Perkins family for four generations. Daniel's granddaughter, Mary Perkins, acquired the property as an orphan in 1778. She married John Wilson, birthed several children and began raising her family in what was always considered to be "home" to her ancestors. But her husband, John, died, leaving her a widow. Mary then married Dr. Alexander Stuart from Delaware, and shortly thereafter, they moved the family to Wilmington, where she continued to have more children. Mary Perkins Stuart died on January 8, 1808, at the young age of thirty-nine. Her family brought her home to White House Farm to be buried. The farm eventually passed to Mary's daughter, and that's where the Perkins legacy ends for White House Farm. After that, the farm changed hands, going through several different families. It fell into grave disrepair.

In the early 1940s, a young couple, Arthur and Catherine Pinder, fell in love with the old house and had dreams of making it their

home. Arthur and Catherine were both raised in Kent County, and both grew up in the shadow of White House Farm. They purchased the old house and property shortly after they were married and lovingly restored it over the next forty years. But they were warned by the owners who sold it to them to "beware." They would not be living at White House Farm alone.

Neither Arthur nor Catherine believed in ghosts, but in their forty-year tenure as owners, certain events occurred that they just couldn't explain. Author Ed Okonowicz—well known for his writings on ghosts and hauntings—writes of an interview he conducted with the Pinders while researching a book. The Pinders spoke of strange noises, footsteps, doors slamming and various unexplained events. One such event occurred when they were painting. They could hear footsteps on the second floor. Certain that no one else was home, they investigated the noises, but they never found the source. Similarly, they would often hear someone enter the house: the door would swing open and then close again, footsteps would sound and then an interior door would close. Both Pinders would agree that they had heard someone come in. Yet upon investigation, they would find no human present. Their French poodles would bark mysteriously at nothing. A door in the cellar would slam shut periodically and set the dogs to moaning and whimpering in fear. The Pinders once told a reporter who inquired about these ominous occurrences, "Well, it's either George or Mary," referring to George Washington and Mary Perkins Stuart.

Another paranormal phenomenon at White House Farm is the "bleeding stone." In a rocky outcropping on the farm is a stone that is stained with a substance some believe to be blood. The owners prior to the Pinders tried in vain to paint over the alleged bloodstain, but it would always return, resurfacing through the paint. Legends state that the stain is the blood of a young servant girl. In the dark of night, she mounted her horse and attempted to ride away from White House Farm to elope with her lover. But as she fled, the horse stumbled. She slid out of the saddle and fell to the ground.

Her head hit a stone and she was killed. The blood from the head injury stained the stone and, to this day, cannot be washed away. The stone still sits on the grounds of White House Farm, but its legend has recently been played down.

In the early 1970s, the Pinders experienced their most stunning unexplained event. Katherine Pinder awoke in the middle of the night, startled from her sleep by a female presence in her bedroom. A woman dressed in a blue nightgown walked—or rather glided—through the room and out of the bedroom door. Katherine woke her husband, Arthur, and asked if he had seen the woman in the blue nightgown. He had not, but he walked down the hall where their grown daughter was sleeping, awakened her and asked if she had just been to their room. He told his daughter that her mother had just seen a woman in a blue nightgown walking in the room. The daughter assured Arthur that she was not the woman, and she had no blue nightgown. Arthur and Catherine chalked this up as the most unexplainable event yet.

True or false, the stories of Mary Perkins Stuart and the bleeding stone have clung to the legacy of White House Farm and caused it to be one of the most written about haunted houses on the Eastern Shore. The Pinders recount stories of farmhands who would not walk the fields in the evening for fear of encountering the ghost of Mary Perkins Stuart. For years, people would stop at White House Farm and ask to see the bloody or bleeding stone—so much so that the stone had to be relocated to an obscure place, out of sight from the general public.

But the ghostly legend that has lasted for years is that Mary Perkins Stuart roams the grounds of White House Farm on the anniversary of her death, January 8. She comes out at midnight and roams until the sun comes up. Rather than being frightened by ghostly presences and tales of hauntings, the Pinders embraced them as part of their home experience. At one time, they gave midnight parties every January 8 to celebrate Mary and her well-

known roaming escapades. Whether Mary roams, whether George Washington walks through the house or whether the young servant girl causes the stone to bleed, White House Farm is known for haunting memories that cling fast to its history.

Mary is buried beside her father on the grounds of White House Farm in an obscure location encroached upon by vegetation and underbrush. We can thank Ed Okonowicz for finding the graves and recording part of Mary's long epitaph: "pious, friendly and humane, amiable in disposition and as a wife and mother most affectionate, soothing and endearing…perfectly sensible and resigned, the last breathings of her soul were, 'come Lord, let us come quickly.'"

Today, White House Farm is a private residence. The owners operate an organic farm and sell turkeys, tomatoes, jelly, fresh figs and heirloom beans.

ST. PAUL'S CEMETERY AND THE GHOST OF TALLULAH BANKHEAD

Chestertown, Kent County

H istoric St. Paul's Episcopal Church is located near
Chestertown. It was built in 1713 in a grove of oak trees on
land offered by a local businessman. It is one of the oldest churches
on the Eastern Shore and has a stunningly beautiful, though
not spooky, churchyard. While most of the graves date from the
nineteenth and twentieth centuries, there are earlier graves, most
of which lie close to the church building. The church is located
off Sandy Bottom Road. Upon entering the parking lot, the visitor
can't help but notice the 120-foot-high swamp chestnut tree that sits
just at the path leading up to the church. The tree is believed to be
over four hundred years old. It is 23 feet, 7 inches in circumference
and approximately 10 feet thick. The 90-foot canopy created by its
spread of branches shades nearly the entire parking lot.

Despite the age of the church and graves, the entire nineteen-
acre parcel is tidy and well kept, with an aura of "sacredness"
about it. The church is currently home to an active faith
community—apparent by the personal attention given to the
buildings and holy grounds around them. The sacred graveyard
is set on a millpond and is populated by forty different species
of trees that include majestic pines, firs, magnolias, oaks, maples
and cedars. Peeking out from under their shady branches are

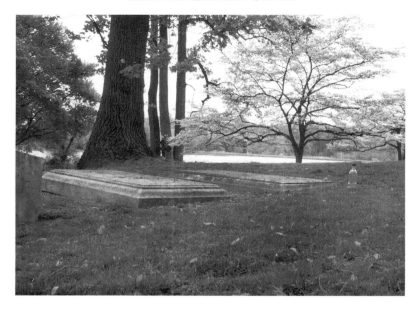

St. Paul's Cemetery, Kent County, looking across the grave of Tallulah Bankhead.

flowering dogwoods, azaleas, boxwoods and ornamental trees. Wandering among the graves is like walking through a forest, with the deep shade and the strong, but comforting, sound of birds. There are two Confederate and three Union soldiers buried here. One remarkable grave near the church is that of Daniel Cohen, who died in 1727. His headstone clearly reads:

> *Behold and see where I now lye;*
> *As you are now, so once was I;*
> *As I am now, so you must be;*
> *Therefore prepare to follow me.*

Though St. Paul's is famous for its trees, its historic church building and its well-kept cemetery, it is also famous for one of its "sleeping" residents: movie star Tallulah Bankhead. Born in 1902 in Huntsville Alabama, Tallulah ended up at St. Paul's for

her final rest because her closest living relative, her sister Eugenia, lived in Rock Hall. The two sisters eternally rest side by side at the northeastern corner—the newer section—of the cemetery. Tallulah was a member of a political family; her father served in Congress as Speaker of the House, and her grandfather and uncle both served as U.S. senators. At age fifteen, Tallulah won a beauty contest and then headed for New York, where she became famous not only for acting but also for her infectious personality, raucous behavior, fast life, salty language and outspokenness.

It was well known that Tallulah used drugs and alcohol to excess. Her biography states that she smoked over one hundred cigarettes a day. One famous quote attributed to Ms. Bankhead is: "Cocaine, habit forming? Of course not, I ought to know, I've been using it for years." It is also known that Tallulah had a fondness for children; she had several foster children from other countries with whom she corresponded and to whom she sent gifts and money. By 1968, she had developed emphysema and went to stay with Eugenia, in Rock Hall. She stayed in a cottage on Eugenia's property and became more depressed as her illness progressed. She returned to her home in New York, where she contracted the Asian flu. Her frail body couldn't fight it, and she died at age sixty-six. Eugenia brought Tallulah's body back to Kent County and buried it in St. Paul's Cemetery. Eugenia died eleven years later and was buried beside her sister. The slabs are identical; only the names and dates are different.

Some people in Chestertown told me that when they were young there was a haunted story attached to Tallulah Bankhead's grave. It was said that if you went down to St. Paul's Cemetery at night and lay down on Tallulah's grave with your ear pressed to the slab, you could hear the dead Hollywood star singing. According to these folks (who were in their forties at the time of the interviews), many a young person pressed an ear to the slab, and many miraculously heard a lyrical singing voice. Oddly, Tallulah was not known for singing or having a lyrical voice. Her voice was raspy and harsh, memorialized in her references to many people as "dah-ling" due

to her self-proclaimed inability to remember names. Lyrical or not, her voice has been heard, and living persons have given me their testimonies.

My senses came alive as I entered this churchyard. It has a mystical character. The shade from trees, the setting on the millpond and the peacefulness of the churchyard are so apparent. Knowing that the church and cemetery were built in an existing oak grove reminded me of the druids in pre-Christian Western Europe who believed that oak trees were sacred but oak groves were mystical. They were home to the gods. They were places where the veil separating this world and the next is thin. There is no coincidence here: St. Paul's Cemetery is a thin place.

I went to St. Paul's to investigate and research the Tallulah Bankhead "enchanted" grave. But I couldn't find the grave. I arrived on a Saturday, so no one was in the office. I searched for two hours through headstones and markers and couldn't find it, so I approached the church to see if it was open in order to sit down and think of what to do. It was open. The church was lovely, with its rich wood and stained-glass windows and the most beautiful light fixtures—a converted gas chandelier. I just sat and thought a minute. Where would the grave be? How could I find it? After a few minutes, it occurred to me look at the far end in the new section. I had assumed that Tallulah's grave would be among the older markers, but I had not investigated the northeastern corner that had the newer graves. I was motivated. I rose from the pew, walked to the door, reached for the knob…and the door opened on its own, without my touching the knob, almost as if someone was on the other side of the door opening it for me. I wasn't frightened; rather, I was comforted. It was as if I had a friend leading me.

Sure enough, I trekked over to the northeastern corner and there were the slabs. Tallulah's grave had an empty vodka bottle placed on the slab near her name. It was offensive. This empty bottle and the practice of lying on the slab listening for the undead voice of Tallulah desecrated her memory and defiled the eternal

resting place of a troubled soul. I removed the bottle, and as I did, I felt like I was being watched. Then I thought that maybe the person who left the bottle was troubled as well and the bottle meant something to him or her. I recalled the "Poe toaster"—the person, dressed in black, who visits Edgar Allan Poe's grave every year in the dark hours of the anniversary of the writer's birth (January 19) and toasts Poe with a glass of cognac, leaving behind three roses and a half bottle of the toasting liquor. Tallulah deserved more than an empty vodka bottle; hers is a sad resting place. I later spoke to the caretaker at the cemetery and asked him about the bottle. He said that during the spring and summer, someone continually places an empty bottle on the grave. If it is removed, a new one will find its way there. The caretaker says that this has been happening for years, though he has never seen anyone placing a bottle there or looking suspicious.

As I left St. Paul's, I paused to take in the feeling of the place. Though there are stones all around that are remembrances of loved ones lost, the vast churchyard somehow manages to overcome the markers of death with a celebration of life. There is a mystical, divine presence here that lifts up the living.

Within this church, the prayers have never ceased,
Tradition lives—no transient people these,
The oldest parish names still live today,
Descendants worship here beneath the trees.
A venerable shrine is this: the trees,
The church, the holy dead beneath the sod
And over all there rests a sense of peace
As though touched by the loving Hand of God.
—from "The Trees of Old St. Paul's," by Nell C. Westcott

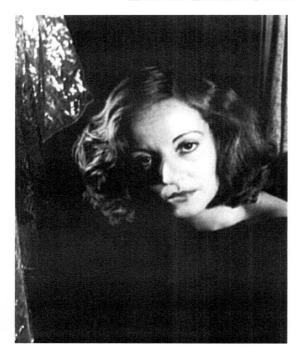

Left: Tallulah Bankhead. *Library of Congress, Prints & Photographs Division, Carl Van Vechten Collection*.

Below: Tallulah Bankhead Marker, St. Paul's Cemetery, Kent County.

THE BRIDGE AT ST. PAUL S CEMETERY

Just past the dam at the millpond is a bridge that is part of the paved road (Sandy Bottom Road) that runs past St. Paul's. This bridge has a history of being haunted. For generations, Kent County natives have told tales of mysterious lights appearing over the bridge in the dark, shadowy figures walking on the bridge and images of a man sitting under a tree by the bridge.

One of the most commonly told tales about the bridge concerns the light that seems to pass over the bridge at night. The light looks like a lantern being carried by a man, sometimes described as a man on horseback and sometimes as a man on foot. Some suspect that the man seen walking is the ghost of Talbot County native Tench Tilghman, a lieutenant colonel in the Continental army of the Revolutionary War and aide de camp to General George Washington. Lieutenant Colonel Tilghman was chosen by General

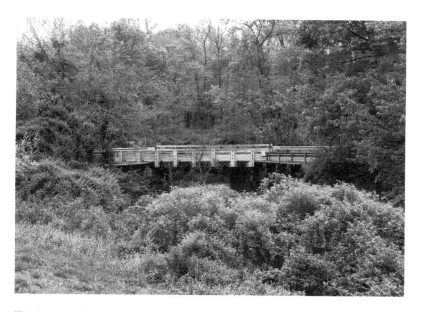

The haunted bridge near St. Paul's Cemetery.

Washington to carry the news of Cornwallis's surrender at Yorktown to the U.S. Congress in Philadelphia. Tilghman left Virginia by boat and sailed into Annapolis, where he caught another boat and sailed into Rock Hall Harbor in Kent County. From Rock Hall, he mounted a horse and rode with frantic speed to Philadelphia, coming straight up the road that passes St. Paul's Cemetery and over the allegedly haunted bridge. Sadly, Tench died a young death at age forty-two, succumbing to a disease that he contracted during the war. He never had the chance to live as a family man, having devoted most of his life to the military and the commitment to a new, free nation.

Tench Tilghman was so committed to fulfilling his purpose during his famous ride to Philadelphia that he rode without stopping, into and through the night, asking local Patriots to supply him with a new horse when he rode his mount to near exhaustion. Some believe that he's still riding and can be seen only at nightfall on the St. Paul's Cemetery bridge.

KITTY KNIGHT HOUSE

Georgetown, Kent County

The beautiful river Sassafras
Flows onward in its pride,
Between the level fields of Kent
And Cecil rolling wide. *

Sometime between 1773 and 1783, two brick houses were built on a hill bordering the Sassafras River in Georgetown, Kent County. During the War of 1812, the British came up the Chesapeake Bay. It was their practice to burn towns that were set on the shores so as to eliminate threats of reprisal against the troops. On May 6, 1813, British forces sailed up the Sassafras River—the river that separates Cecil and Kent Counties—and burned Fredericktown and Georgetown.

Catherine Knight, known as "Kitty," was born into a wealthy, prominent family in Kent County. She frequently visited Philadelphia (then the capital of the colonies) and associated with influential people. Writings from Kitty Knight were found referring to a visit she made to the theatre in Philadelphia. She was escorted by Benjamin Harrison, who was then governor of Virginia, and met and spoke to George Washington, who (according to Miss Knight's writings) appeared to be quite captivated by her beauty and charm.

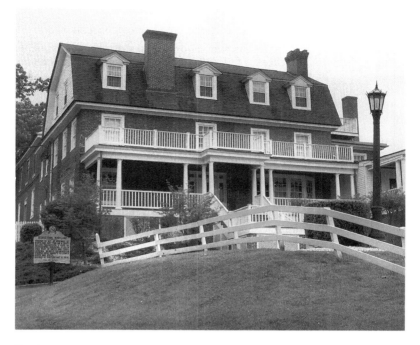

The Kitty Knight House near Galena, Kent County.

Though Miss Knight was from the refined upper class, she possessed humility and stubbornness that had an impact on Maryland history. She convinced a British admiral to stop his forces from burning her town, in particular those two brick houses on the Sassafras River. The British soldiers were banging on the doors in Georgetown, telling everyone to leave as they set fire to the homes. When soldiers arrived at the houses on the hill, Kitty Knight pleaded with them to stop as she put out the fires. The soldiers ordered her to leave, and she said, "I shall not leave; if you burn this house, you burn me with it." The soldiers continued to try and ignite these houses, and Kitty Knight continued to put out the fires and beg. Finally, she was able to ask Admiral Cockburn, commander of the British forces, to halt the burning of these two houses. She claimed that there was an elderly woman who could

not leave and would be burned with the house if they were to set it on fire. For reasons known only to those who were present, the admiral ordered his troops back to the barges, and the two houses and a church were spared destruction.

At the time, Kitty Knight didn't own either of the houses, but she did purchase one of them later. Her legendary heroism during the burning of Georgetown has been recounted often and recorded in the annals of Maryland history. In 1924, Herbert Stine from Washington County, Maryland, purchased the Kitty Knight House. Four years later, he purchased the house next door and proceeded to join them together. The two houses became one property and were converted into an inn and restaurant known as the Kitty Knight House.

> *"Spare them their little homes I plead,"*
> *Her eyes were sparkling bright;*
> *They rested on the admiral,*
> *And-well! they stopped the fight.*
> *Tradition sings a sweet old song,*
> *A song of long ago,*
> *That Kitty Knight, of Georgetown,*
> *Struck then a fatal blow.* *

Today, the Kitty Knight House operates as a full-service inn and restaurant, with panoramic views of the Georgetown Harbor and the Kent and Cecil County landscapes. It is a popular place for the local community to dine, as well as a destination that attracts visitors who come by boat and from out of town. But the locals and the staff will admit—as have previous owners and staff—that Kitty Knight seems very much "alive" at the Kitty Knight House.

For years, Kitty Knight House staff and owners have said that doors open and close by themselves throughout the building. A dining room manager reported having seen the shadowy, ephemeral figure of the former lady of the house standing by the door. The

former owner of the Kitty Knight House said that when he was outside the building, he would often see lights on in the second- and third-story rooms that he knew had not been booked. He would see people walking around in the rooms. Upon investigation, he would find the rooms empty and the lights off.

A travel writer who stayed in Room 4—the room thought to have been Kitty Knight's bedroom—wrote that when the innkeeper showed her to the room, the door closed by itself as soon as they entered. The innkeeper said that if Kitty likes you and wants you to stay, she will close the door. The same travel writer recounted that a staff member told her they had to remove Kitty Knight's rocking chair from the room because guests complained about it rocking on its own.

The current manager of the inn told me that as recently as a week prior to our interview she was with a visitor in the business office and the phone rang. She could see that the call was coming from Room 4, Kitty Knight's Room. She answered the phone. No one was there. The room was not booked. When staff investigated, they found the room locked. They entered the room and found no one there.

Whether Kitty Knight's spirit haunts her old home and the surrounding grounds is uncertain. There are some who claim to sense her presence and others who attribute unexplained events to her doing. What is certain is that the eighteenth-century icon that is the Kitty Knight House conjures up memories of the heroic, beautiful, courageous woman who persuaded the British to retreat from their battlefield and thus saved a small piece of her hometown.

The British fleet has sailed away,
Adown the shadowy past;
Now, only memories drift along
The lovely Sassafras. *

*From "Ballad of the Sassafras River," by Rosalie Mitchell Schuyler, 1911

KENT MANOR INN

Stevensville, Queen Anne's County

The oldest part of what is now the Kent Manor Inn was built in 1802. It lies just across the Chesapeake Bay from Annapolis in the town of Stevensville in Queen Anne's County. In 1843, Alexander Thompson's mother deeded him 307 acres, which included that original part of the building raised in 1802. The area was named Thompson Creek after Alexander's family and is still known today by that name. Shortly after receiving the property, Alexander added the center portion of the inn: a two-and-a-half-story addition, with four rooms on each of the first and second floors and five small rooms on the third floor, capped by a cupola, from which nearly all the acreage, as well as miles of shoreline, can be viewed. All of the rooms on the first and second floors had fireplaces with ornately carved marble mantles.

Alexander was a wealthy, flamboyant, cigar- and pipe-smoking dilettante who loved fine things and social events. He often entertained in his lovely manor house. He was known for riding a white horse and being quite the lady's man; he was married three times, though he never had children. Alexander died in 1875 at age sixty and is buried in Stevensville. But owners, workers and guests at the Kent Manor Inn believe that Alexander is quite present at the inn even today.

The property went through a chain of owners and fell into disrepair. Tales of haunting and unexplained events surfaced,

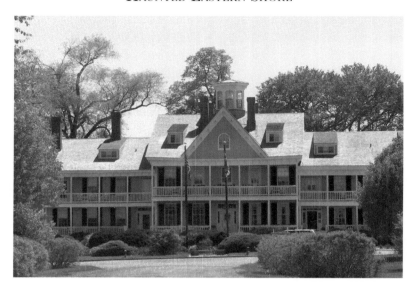

The Kent Manor Inn after renovation, Queen Anne's County.

including people stating that they had seen the long-dead Alexander Thompson roaming the property on his white horse. In 1987, the building went through much-needed renovations, and in 1988, the new owners converted the house to an inn. They were approached by locals, among whom were some members of the Thompson family, who asked if Alexander Thompson was ever seen riding his white horse on the property. Though they hadn't seen the horse, they did have many unexplained events to discuss.

There were instances of guests' luggage disappearing and unexplained noises. Each of the twenty-four guest rooms would be locked by the innkeeper at night, only to be found unlocked and opened the next morning. Strange noises were heard by staff and guests alike. The inn was purchased by its present owners in 1995, and the strange activities continued. Unexplained sounds, doors opening and closing and the lingering scent of tobacco and cigar smoke in some of the rooms in this nonsmoking facility continued to support the belief that something—or someone—was haunting the place.

In 1998, the innkeeper went to her car one evening and noticed the lights on in the Presidential Suite. She knew that she had checked all the rooms and extinguished all lights. She returned to turn off the lights, and when she entered the room, the lights were off. A maid entered room number 303, which was supposed to be vacant, and saw a man in farmer's clothes standing in the room. A mother and daughter were watching television in their room when it suddenly went off. They asked for staff assistance. When the staff member entered the room, the television came back on. He sat with them for over an hour and the whole time the television worked fine. As soon as he exited the room, the television went off again. Guests staying in room 209 (the most haunted room) have reported that it feels as if they are being watched, and lights frequently go off and on, independent of human activity.

Dave Meloy, one of the partners who currently own the Kent Manor Inn, stated in an interview that unexplained events were occurring there and that guests and staff could recount some of the details. Some staff claimed to have seen apparitions of Alexander Thompson, and female workers complained that they had been inappropriately touched—or "goosed"—by Alex as they ascended stairways in the inn. However, they found an old photograph of Alexander Thompson, enlarged and framed it and then hung it in the hall so that, according to Dave Meloy, "everyone who comes and goes gets a chance to see that Alexander was the progenitor of this lovely building as it stands today." Things quieted down after the portrait was hung.

One night, a receptionist felt a breeze coming down the stairs. Upon investigating, she discovered room 209 with the door open. She closed the door, locked the room and returned to her station. The breeze commenced again, and again she ascended the stairs to find the door to room 209 open. She closed and locked it and returned to her station for a second time. Momentarily, she felt the breeze again, but this time she yelled, "Okay, Alexander, I know it's you so knock it off!" The room stayed locked for the rest of the night.

It appears that Alex likes the attention.

Today, the Kent Manor Inn has twenty-four luxury guest rooms, two conference rooms, a garden room, a restaurant and beautiful grounds. It is often the setting for weddings, outdoor parties and business meetings. Evidently, the ghost of Alexander Thompson hasn't deterred business.

BLOOMINGDALE

Queen Anne's County

Bloomingdale is a Federal-style, two-and-a-half-story brick mansion built in 1792 that lies halfway between historical Queenstown and Wye Mills in Queen Anne's County. When Captain Robert Morris patented land in 1665, it was known as Mount Mill—a name that was passed on to the mansion. In 1835, Miss Sallie Harris and her sister, Mary, inherited the property. Miss Sallie, according to a news article published in the *Baltimore Sun* in 1912, reigned as the queen of the Baltimore social scene and was the center of the most brilliant Republican court, keeping company with the historic Caton sisters, who became the Duchess of Leeds and the Marchioness of Wellesley. Clearly, Miss Sallie was one of the most important women of her time. Retiring from this fast life, Miss Sallie found comfortable seclusion at Mount Mill, which she promptly renamed Bloomingdale once she took ownership. She and her sister ran the estate with competence and precision, while still keeping a small circle of influential social acquaintances.

In 1879—one year before Miss Sallie's death—a strange occurrence happened at Bloomingdale. So strange it was that a Queen Anne's County newspaper reported the incident as told by an eyewitness, and the locals have been talking about it for the last 130 years. The newspaper recounts the story as follows:

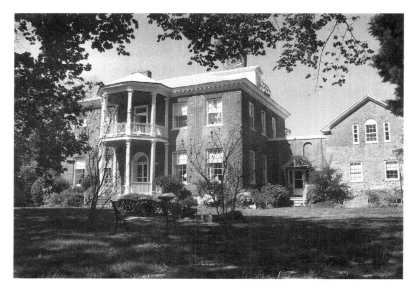

Bloomingdale, also known as "Mount Mill," located in Queenstown, Queen Anne's County.

One night after Miss Sallie Harris and her guest, Mrs. Nancy DeCourcy, had retired, a rap was heard at the front door about 11 o'clock. Both ladies were very much frightened, but finally Mrs. DeCourcy opened the door and was confronted by the "ghost" of William Sterrett, a deceased nephew of Miss Harris. Mrs. DeCourcy stood staring in speechless horror at the object until it moved down the hall and beckoned her to follow. Mr. Sterrett's spirit passed through the house, with Mrs. DeCourcy closely following, until it came to the door of the room in which Mr. Sterrett had slept when living [at Bloomingdale]. Then suddenly it disappeared.

Mrs. DeCourcy's screams of terror brought Miss Harris and a crowd of servants quickly to her side. The door through which the "spirit" had vanished was securely locked and the key was in Mrs. DeCourcy's possession. The lock was soon turned and upon entering the room, they found that it was apparently

unoccupied by the apparition. The bed, however, was tumbled as if someone had just risen from it. Nothing more was seen of Sterrett's ghost. After that, a thorough search of the house failed to disclose the presence of anyone who did not have an undisputable right to be there.

There are several other versions of the story that have Mr. Sterrett appearing soaking wet. He died in a drowning accident at the millrace. The same version goes on to tell that the bedclothes in Mr. Sterrett's bedroom were soaked and the path he followed through the house was damp from his dripping clothes.

Miss Sallie died the following year and willed the property to her cousin, Severn Teakle Wallis, who was the cofounder of the Maryland Historical Society. The Harris family cemetery survives on the Bloomingdale estate today and is surrounded by old American boxwoods. Years after the Sterrett incident, residents, workers and visitors to Bloomingdale claimed to see William Sterrett and Miss Sallie Harris roaming the grounds and the mansion. I spoke with Mrs. Marty Willis, the current owner of Bloomingdale. She gave me a tour of her beautiful home and a little of the history. Mrs. Willis does not claim to have seen an apparition of either William Sterrett or Miss Sallie, but she does feel Miss Sallie's presence in the house often. She said, "I can sense Miss Sallie moving about the house, making sure things are in place. She's definitely here."

Bloomingdale looks much as it did for the last two hundred years. It is the only Colonial home in Maryland with a two-story hexagonal entrance porch. Renovations have reinforced the porch while changing little of its design. Though it is located on a busy highway, the surrounding farm acreage and large trees that line the driveway still give Bloomingdale a secluded feel. Currently, the Willis family leases the property for weddings and private parties.

THE TALE OF WISH SHEPPARD

Denton, Caroline County

In July 1915, Aloysius "Wish" Sheppard was arrested for raping young Mildred Clark of Federalsburg. Later that year, he was convicted and sentenced to death by hanging. Wish Sheppard lived in Federalsburg with his mother and was approximately nineteen years old at the time. He confessed to the crime but later recanted, stating that he was coerced into confessing: he was threatened with being released into the hands of an angry mob if he didn't confess. And the mob *was* angry.

Originally, the hanging was set to be held inside a barn near the Denton jail and courthouse, with no public audience and only a few witnesses who were close to the case. However, the venue was changed to "outdoors" once rumors surfaced about a mob, hungry to watch the rapist hang, intending to burn down the barn the night before the scheduled execution. Wish was hanged from gallows erected on a slight slope behind the Caroline County Jail in Denton just along the Choptank River. Hundreds attended the hanging and observed the gory event from the ground and from boats on the river; some spectators even hung from the trees. The event has been memorialized in two commemorative postcards, both entitled "The Hanging of Wish Sheppard." One shows the condemned man on the scaffold, and the other shows the scaffold

Wish Sheppard,
nineteen years
old, awaiting trial.
*Courtesy of Sonny
Callahan.*

with the trapdoor open and the rope pulled taut, with the obvious (though not visible) body at the other end.

The hanging of Wish Sheppard in 1915 was the first legal execution in Caroline County in nearly one hundred years—and it was the last.

As the tale goes, Wish Sheppard vehemently resisted his final walk to the gallows. He gripped the cell bars with one hand and pressed the other flat against the cell wall, and the guards had to pry his body out of the jail cell to march him to the gallows. (This resistant behavior has been refuted by eyewitnesses, but it makes a good story.) Regardless of how Wish left his cell, a handprint remained on his cell wall. After the execution, there were many

attempts to cover over the handprint both with paint and plaster, but it always resurfaced. Over the years, prisoners and guards have reported strange occurrences and spooky incidents attributed to Wish Sheppard haunting the Caroline County Jail in Denton.

Retired sheriff Louis Andrew has been interviewed numerous times regarding the Wish Sheppard haunting of the jailhouse in Denton. Sheriff Andrew moved into the sheriff's living quarters in the jail when he was ten years old and his father became the sheriff for Caroline County. In those days, the sheriff and his family lived at the jail and provided for the prisoners. In 1961, Louis Andrews succeeded his father as sheriff, and though he never saw Wish Sheppard or had any direct contact with paranormal occurrences, he can recount dozens of experiences relayed to him by prisoners and guards at the jail.

Sheriff Andrew recalls trying to paint over the handprint numerous times, but it would always eventually resurface through

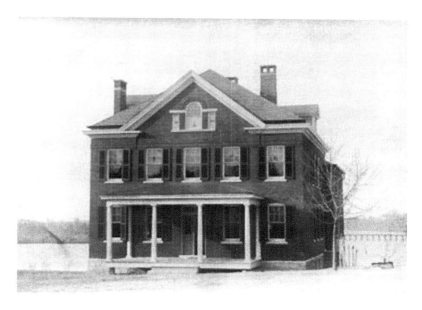

Caroline County Jail. *Courtesy of Sonny Callahan.*

the paint. He even put cement across it once, but the handprint returned. Prisoners would awaken the sheriff in the early hours of the morning, scared to death, saying that they saw the ghost of Wish Sheppard, heard footsteps or chains clanking or glimpsed a shadowy figure walking by. The sheriff would have to go all around the jail with his flashlight, showing the prisoners that no one was there. On one occasion, a prisoner claimed that the ghost came into his cell and attacked him. The cell door had been locked all evening, and no one else was in the cell. But the prisoner had scratches all over his arms and face. The door to the Wish Sheppard cell would never open easily. The cell wasn't used.

The jail was remodeled in the early 1980s. According to Sheriff Andrew, during the renovations another wall was erected over the one with the handprint, and the jammed door to Wish Sheppard's cell was simply kept in place while the renovations went on around it. The renovations seemed to bring an end to the torment of prisoners by whatever ghostly presence dogged the jail; instead, the torments were redirected to jail staff and guards. Many workers report seeing the figure of a man in the security monitors. When a guard would go to investigate, he would find no one there. Others report that the elevator operates by itself in the wee hours of the morning, with no one riding on it. A cold chill has been known to fill the rooms. Footsteps are still heard in the halls, and lights still go off and on mysteriously. Most people who work in the jail are used to it and say to themselves, "It's just ol' Wish Sheppard checking things out."

THE MURDER OF SALLIE DEAN

Harmony, Caroline County

O n March 26, 1895, thirteen-year-old Sallie Dean didn't make it to school. Instead, she was accosted on her way by someone she knew and trusted. Her bloody body was found by her father in a wooded area later in the day. Her throat had been slashed. This happened near the tiny Caroline County village known as Harmony, which lies south of Denton, about halfway between Denton and Preston. The local authorities could not pin down a murderer, so as the local community grew increasingly antsy, Baltimore detectives were brought in to investigate. They quickly apprehended the local blacksmith, Marshall Price, a twenty-three-year-old married man who lived in the vicinity of the dirt road on which Sallie Dean walked every morning on her way to school.

Marshall Price denied guilt immediately. While in custody, however, he changed his story and admitted to committing the crime, but he implicated another neighbor—Grant Corkran—as the mastermind. Price even defiled the victim in death by claiming she was unchaste. Eventually, Grant Corkran was cleared, and Marshall Price was sentenced to hang for murder. Finally, Price gave everyone what they wanted: the true confession. He was evidently hoping that by coming clean with all of the facts, the judge would grant him a reprieve. In his confession, Price actually commended

A sketch of Marshall E. Price from the *Denton Journal*, 1865.

himself for not "violating" the young woman sexually, even though he murdered her. The following is a transcript of the confession by Marshall Price as reported in the *Denton Journal*:

I want to tell you something, (and after hesitating he extended his right hand and said,) The detectives said Sallie's throat was cut by a left-handed man, I want to say that this is the hand that cut her. When I came out of the woods after cutting the material for the frames, I crossed the road about ten feet behind Sallie who was on her way to school. She spoke to me pleasantly and remarked it was a lovely day. I joined her and walked a short distance conversing upon matters of no importance. A sudden impulse took possession of me. Without warning I raised the axe which I carried in my hand and struck her on the side of the head. She fell on the ground partly stunned. I dragged her to one side of the road and cut her underclothing, then tore the clothes with my hands. She revived about this time and said, "Oh, my head…how it hurts." I then caught hold of both of her hands and dragged her to the woods, cut her throat but I did not violate her person. I covered her body with a cedar bush and buried her dinner bucket and the knife with which I cut her throat. I WAS ALONE. Grant Corkran had nothing to do with the murder.

After the body was found I took an active part in the search for the murderer thinking I could in that way divert suspicion from myself. The detectives were too smart for me though. When I got to Baltimore I decided to confess to the U.S. Marshal implicating Grant Corkran partly for revenge because Grant got the better of a trade we made—and partly because the people of Caroline County would lynch me if they thought I alone committed the murder.

About a month after this confession, the governor of Maryland granted Price a reprieve due to a legal technicality. This enraged the local people. Marshall Price knew that the mob was coming

for him, and the poor jailer knew that he and the minimum security jail were no match for the angry mob that descended to inflict its own brand of justice on Sallie Dean's brutal killer. Price pleaded for the jailer to turn him loose, promising that he would only hide and not try to escape. As the mob entered the jail, Price cowered in the corner of his cell, weeping like a baby and praying for mercy. The mob broke into the cell, put the rope around his neck, beat him nearly senseless and ended his life by hanging him from a tree behind the courthouse. Marshall Price was buried in the Denton Cemetery in a portion that was not in use at the time. He and Annie Belle Carter (see chapter on Willson's Chance) are the only two buried in that cemetery in graves that face east–west. Marshall's head is at the eastern end so that when he rises on judgment, his back will be to his maker. All other graves are placed in a north–south direction. Price's headstone is inscribed:

Marshall E. Price
Died
July 2, 1895
Aged
23 years and 7 days
Our only one is laid to rest,
In peace with God forever blest.
In peace with God his glory doth shine.
Forever blest in God divine.

All of the men who had a direct hand in lynching Marshall Price died horrendous deaths, and all within five years. One burned to death, one drowned and another was struck by lightning. It has been said that the tree from which Marshall Price was hanged died shortly after the lynching. Also, the tree next to his grave died within a year of his burial. Since Price's death in 1895, young people in Denton, upon hearing an urban legend that Marshall Price's spirit returns to dance on his grave on moonlit nights, have snuck off to

the cemetery during the full moon to stake out Price's grave to see if he would return. So far, no one has reported seeing Marshall dancing by the light of the moon.

In June 1989, the *Star Democrat* reported that the owners of the Dean home—the home where Sallie Dean was raised—were experiencing eerie events that conjured up memories of the teenager's murder. Ralph and Karen Collins, who had been living in the house for eighteen years, told reporter George Hulseman, "Every once in a while we'll hear something that you can't explain." The Collinses went on to report that when they moved in 1971, they noticed on the wooden floor of the living room a large stain, which they believed to be a discoloration caused by young Sallie's blood. The murdered child was brought to her home, having had her jugular slashed, and was kept there for several days after the murder. When the Collinses decided to install new carpet, Mr. Collins placed a three-quarters-inch plywood subflooring over the stained wood floor. Carpet was then installed. Years later, when the Collinses decided to remove the carpet, they found a stain in the new plywood directly above the original bloodstain. Mr. Collins stated, "That dried blood had come through three-quarters-inch plywood...Can you explain that?"

Another strange incident occurred when a large wall mirror came off the wall in an upstairs room and was found on the floor on the other side of the room. The most recent event occurred when Mrs. Collins thought she saw something come down the stairs. She states that she was sitting in the living room at the time, when one of the cats appeared to be staring at the stairs. As she looked up, she saw a mass, with no distinguishable shape, descend the stairway. Over the years, the Collinses declared that they heard unexplained sounds from other parts of the house, sounds that included windows opening and closing. They have smelled musty odors emerging from the original section of the house.

The Collinses admitted to Mr. Hulseman (the reporter) that though the events were indeed strange and eerie in light of the

house's history, they believe that there's probably an explanation. They also admitted that as of June 26, 1989 (the date the article appeared in the *Star Democrat*), there had not been any strange occurrences for over ten years. Mrs. Collins stated, "It seems the more we do with the house, the less we hear…I do hope she's at peace, wherever she's at."

> *In this quiet shady spot, So dear to misty human eyes,*
> *Where sleeps the dead, by some forgot, Our buried treasure lies.*
>
> —*From* Epitaphs—*Folklore Collection, Nabb Center, Salisbury University*

ATHOL CHILD'S GHOST IN HENDERSON

Caroline County

In 1753, a man named Richardson from Somerset County, Maryland, patented 600 acres in Caroline County—the part that is now known as Henderson—and named it Athol. In the late 1700s/early 1800s, William Jones built a brick house on the property with two protruding chimney stacks, one on each of the gable walls. Today, the house sits in the middle of 255 acres of agricultural land and is owned by John Wilson, who has a master's degree in historic preservation. The Wilsons have taken great care to restore the home to its original footprint. The Maryland Historical Trust states that this house—referred to as Athol—is one of the few houses in Maryland that displays an accurate picture of what agricultural space looked like in the late eighteenth and early nineteenth centuries.

When John Wilson researched the history of the home—both written and oral histories from local people—he discovered that, in 1838, an owner's will shows that the estate had fourteen slaves, ranging in age from seven to twenty. The majority of the slaves were valued at $200. One slave, listed only as "Rachel" and born in 1783, was valued at $1. Mr. Wilson believes it likely that Rachel was either first- or second-generation African American. He also believes that she was probably a slave who lived in the house close

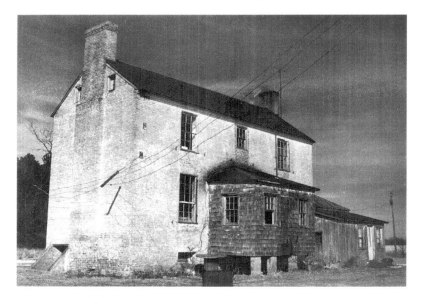

Athol, the site of a child's ghost voice, Caroline County. *Courtesy of the Maryland Historical Trust.*

to the family, as there are architectural indications that someone resided in both the attic and the basement. He believes that she may have been valued at only $1 because the family didn't want her sold as she had become part of their family. The old cemetery for the plantation slaves is across the field from the house. It still has a grove of trees growing there.

When the real estate agent assisted the Wilsons in buying the house in 1998, he told them that two little girls who lived in the house had died of typhoid fever in the 1880s. He pointed out their unmarked burial spot in the front yard. John Wilson says that there is a spot in the front yard near where the real estate agent pointed that is somewhat sunken. Also, old daffodils spring up near the spot every year. John Wilson's son lived in the house for five years with his wife and small child. The son pointed out some unexplained events that occurred in the house during that time.

Once, in the middle of the night, John's son was awakened to the sound of a dog barking downstairs in the dining room, but the family had no dog, and the house had no neighbors for miles. John's son investigated and found nothing—no dog. On another occasion, John Wilson and his wife were chatting in the same dining room with their son and daughter-in-law. It was late fall, near dusk. The sun was setting, but it was still light outside. At a lull in the conversation, all four adults in the room distinctly heard a child cry out, "Ma!" The cry seemed to be coming from the area around the dining room window. They investigated, searching around the outside of the house, but no child was in sight.

A few years later, the family was gathered at the house for a Christmas party, and John relayed the story of hearing the child cry out when they were all in the dining room. A guest named Brenda (the mother of John's daughter-in-law) was shocked to hear the story. Brenda had been down at the house in the summer cutting the grass. She took a break and went into the kitchen for a glass of lemonade. While sipping her drink, she distinctly heard a child's voice cry out, "Ma!"—but there were no children in the household. Brenda, just like the others in the previous incident, investigated outside but there was no child to be found.

When John's son and daughter-in-law had their baby in the house, they used a baby monitor. Through the monitor, they could hear a woman's voice speaking very softly. Naturally, they rushed into the baby's room but no one was there.

John Wilson states that he is not a believer in ghosts, but they heard what they heard. There is no known explanation. The Wilsons love the home and continue to use at as a place of retreat. The unexplained occurrences do not deter from the peacefulness of the house or property; they merely enhance it and give depth to the sense of history of the place.

WILLSON'S CHANCE AND THE GHOST OF ANNIE BELLE CARTER

Denton, Caroline County

I n 1732, the patent for Willson's Chance was issued for twenty-two acres in what is now the town of Denton. It was there that a Quaker named James Willson built a home about 1750. Local historians believe that early Caroline County Quakers used this home as a place to meet before building the Tuckahoe Neck Meetinghouse. Prior to the Civil War, Colonel Richard Carter purchased the home, and it was in this house that his daughter, Annie Belle, fell to her death from the second-floor balcony. Colonel Carter was an influential man in the region, being the commander of a local state militia, as well as an advisor to President Polk.

According to local oral history handed down over the generations, seventeen-year-old Annie Belle Carter returned from Europe to her family home, Willson's Chance, in July 1882. She had been studying art in England and the Netherlands. On July 26, she woke up feeling ill and walked out to the second-floor porch for some relief from the summer heat. As she leaned against the rail, she fainted and fell over the railing. A tree had been cut earlier that day, and Annie fell on the tree-root system and was pierced by some of the roots. She died from her injuries within a few days. Mrs. Mary Ann Walsh, the current owner

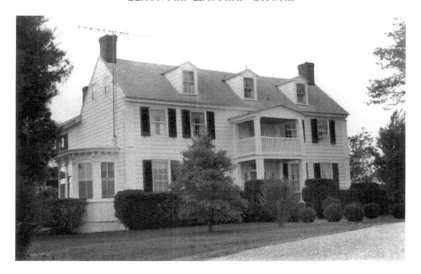

Willson's Chance, home of Annie Belle Carter. *Courtesy of the Maryland Historical Trust.*

of Willson's Chance, met Carter family descendants when they returned to their ancestral home for a visit. The Carter family gave Mrs. Walsh information on Annie's death, as well as a special thank-you gift for her hospitality and graciousness in receiving them. The gift was one of Annie Belle's paintings; it hangs today in Willson's Chance.

Mrs. Jonathan Hughes, a retired schoolteacher living in Denton, relayed a different version of the death story to a Salisbury University folklore student. Her version states that Annie's father arranged her engagement to a man she didn't love. Before the wedding, which was to be held at Willson's Chance, the young bride came down the stairs and told her father that she couldn't go through with it. Her father became angry and demanded that she not disobey. He ordered her to ready herself for the wedding. The young woman went upstairs, succumbed to her grief over marrying against her will and threw herself off the second-floor balcony. She fell to her death by committing suicide. Mary Ann Walsh states that Mrs.

Hughes's story is true, but the young bride was not Annie Belle; it was a girl from the Cade family, who were tenant farming at Willson's Chance prior to the Carters buying the property. So it appears that two young women have fallen to their deaths from the Willson's Chance second-floor balcony.

There have been sightings of Annie, dressed in white, standing on the balcony and sightings of her dancing in the front yard of Willson's Chance. Most of these sightings stem from African American religious revivals that were held in a building directly across the road from Willson's Chance. Those who attended these revivals would sing and play music. During the music, some would notice a woman in white dancing on the Willson's Chance lawn. Her white dress was bright in the moonlight and highlighted her graceful moves.

Mrs. Mary Ann Walsh has lived at Willson's Chance since 1963, and she confesses that she has had no encounter with Annie Belle Carter or any other ghosts, for that matter. However, she remarked that her grandson, Bill, saw an apparition in her home when he was four years old. He woke up screaming that he saw a lady dressed in white in the room nearby. This room was the same one that opens on to the second-floor balcony. The woman—or apparition—was gone by the time Mary Ann entered her grandson's room.

Annie Belle Carter's father was grieved at the loss of his only daughter. At the time of her death, he was on the committee that was forming the new Denton Cemetery. Annie Belle was one of the first people buried there. All of the graves are laid out to face north–south. Colonel Carter had Annie buried lying east–west, with her feet facing east, so that on judgment day, when all souls rise, Annie will rise with her face to her maker. In 1895, Marshall Price, the lynched killer of young Sallie Dean, was also buried in the cemetery in an east–west direction, but Marshall's feet are pointed to the west so that he will rise on judgment day with his back to his maker. These are the only two graves in the entire cemetery laid in an east–west direction.

Annie Belle Carter's headstone is ornately carved with flowers and ferns, with a tree stump mixed in. Some believe that the stump is a reminder of what caused her death. At the foot of her grave, the following words are inscribed in stone: "So many hopes lie buried here."

THE LOST CITY OF DOVER

Talbot County

On a small patch of wooded land, just off a dirt road that is now owned by Easton Utilities, are two old headstones. Both are surprisingly red, evidently made from red sandstone. Both have eerie images etched above faded epitaphs that remember children of the Harrison family. The first marker is topped with the clear image of a skull crowned with laurel leaves, sporting over-sized sunken eye sockets above a perfect row of teeth. The teeth seem to bite a full spread of batwings. Below the wings, Samuel Harrison is faintly memorialized as an eleven-year-old boy who died in 1754. The second marker is less grotesque and is topped with an angel rather than a skull. But the angel has an angry face that bulges out of the stone. The face is set against a span of feathered wings. Below the angel are almost completely faded words that recall Rachel Harrison, who died on October 3, 1739. She was five years and ten months old. These grave markers are apparently the only visible remains of the lost city of Dover.

While researching both of these graves and the lost city of Dover, I found information that shows there were once four graves in this spot—all children's. One was toppled over; it marked the grave of Daniel, son of Elizabeth Harrison, who died in 1740 at age fourteen years, eleven months. Another was standing but was illegible. On

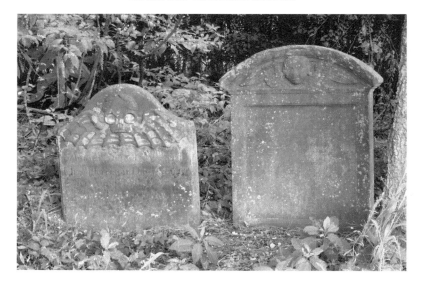

The Harrison graves in Dover Cemetery, circa 1740.

my visit, I saw only three graves: those of Rachel and Samuel Harrison and one that was illegible. The batwing stone (Samuel's) is most unusual, and it is said that it is the only one of its kind on the Eastern Shore and perhaps in all of Maryland. Local historians told me that they believe there was another batwing stone in that same small cemetery at one time, but it was stolen. Some even say that it showed up in St. Michael's on the western side of Talbot County. If so, its owner has put it into hiding, away from prying eyes that would bring charges of theft. The remaining stones are well protected in this small clearing at the edge of the forest, now on private property, but these ancient grave markers are reminders of a thriving colonial town in Talbot County that has now vanished.

According to information in *Ghost Towns of Talbot County* by James Mullikin, an eight-hundred-acre estate was surveyed in November 1663 for Daniel Jenifer on the north side of the Choptank River. This same estate came to be known as Dover. A further notation shows that the property was broken up among five owners, with

450 acres—the largest single portion—going to William Harrison, no doubt the ancestor of Rachel and Samuel, now buried beneath the sandstone markers. Today, the area is on the south side of what is known as the Dover Bridge, which crosses the Choptank River and connects Talbot with Caroline County. The small cemetery is in this same region. Many believe that the Dover Bridge, which is also Dover Road, is so named because it leads to Dover, Delaware. But the truth is that both the bridge and the road are named after the now vanished settlement of Dover that sat on the Choptank.

We know that in 1750 the Dover area was well populated and had grown to be of considerable importance. Both shipping—up and down the Choptank—and residential living had developed a string of merchants and a ferry system that brought residents to other settlements on the Caroline County side of the Choptank River. Oxford was the main port city at the time in Talbot County and was much more accessible to Annapolis and Baltimore. Oxford also had the only customhouse, so it proved to be a more convenient port for imported goods.

The Reverend Thomas Bacon, who was pastor of the old Whitemarsh Church, lived in Dover. The church lay halfway between Oxford and Dover and served as the parish for both towns, as well as the entire area we now know as Trappe.

Dover became so prosperous that, with Oxford, it was vying to be the eastern capital of Maryland and the county seat of Talbot County. But as the village of Talbot Town—now known as Easton—grew, Dover slowly faded into the background until it disappeared all together. According to James Mullikin, the last time the name "Dover" was seen in print referring to the lost city was in March 1796. An advertisement appeared in the Easton newspaper, noting that "a school-master is much wanted in the neigbourhood of Dover, on Choptank River, in Talbot County, Maryland, four miles above Easton." The town must have perished quickly after the advert mentioned here because Dover doesn't appear on the map of Maryland published in 1795 by Dennis Griffith.

In *The History of Talbot County Maryland 1661–1861*, by Oswald Tilghman, the Harrison family of Dover is mentioned. Mr. Tilghman explains that the Harrisons were part of the large Quaker, or Friends, population that settled in Talbot County. His book details a recorded marriage between John Leeds of Wade's Point to Rachel Harrison, Quakeress, on February 14, 1726. In attendance were William Harrison and Elizabeth Harrison. (Could this be the same Elizabeth Harrison mentioned on the tombstone as the mother of Daniel Harrison, who died at age fourteen in 1740? We don't know, just as we can't be sure what happened to the lost city of Dover or even identify its exact location.)

Many have searched for the lost city, but none has found adequate proof of its exact location on the Choptank. Some claim to have seen foundations from small aircraft, and author James Mullikin claims to have seen depressions in the ground that "might have been the filled-in remains of cellars of ancient buildings…and old pilings which might well have been the supports of Dover's once busy wharves."

The only remaining artifacts that can be properly traced are the tombs of the Harrison children marked with angels and skulls— batwings and feathered wings—placed in red sandstone as a remembrance of the innocence of children and the heartbreak of their passing too soon.

WHITEMARSH CEMETERY

Trappe, Talbot County

The old Whitemarsh Church was first attended in 1665. It is said that the church was built with English bricks brought over on clipper ships. The bricks—and all other supplies—would have been paid for in tobacco, which was the currency of the day. The church was built strategically on a main road that linked Oxford to the lost city of Dover, two centers of population in the seventeenth and eighteenth centuries. The church was located about halfway between the two port towns and also served as the parish for the entire region we now know as Trappe. In 1692, the Maryland General Assembly made the Church of England the state church, and the Episcopal Province of Maryland was divided into thirty parishes. Whitemarsh was the only existing church in the new parish. The parish's designated boundaries were the Tred Avon and Choptank Rivers and a line from Tuckahoe Creek on the Choptank to the Tred Avon.

In 1722 and 1751, the church was enlarged to accommodate the growing population, but as Episcopal churches sprung up in Easton, Oxford and Trappe, the Whitemarsh Church fell into disrepair and lost much of its congregation to nearby sprouting villages and towns. In 1897, the old church caught fire and the building was destroyed, leaving only the brick ruins seen today

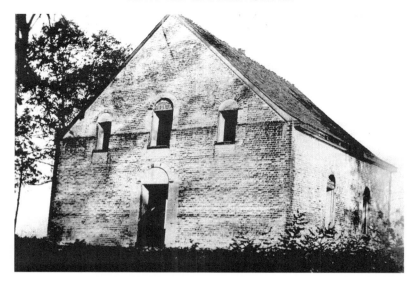

Whitemarsh Church (now destroyed). *Courtesy of the Talbot County Free Library.*

by those who drive down Route 50 at the Maynadier Road crossing.

Records show that Reverend Daniel Maynadier served as the rector for Whitemarsh Church from 1714 until his death thirty years later in 1745. He was a French Huguenot who had fled France sometime after 1685, when the Edict of Nantes was revoked and Huguenot churches in France were ordered to be destroyed. He met and married Hanna in 1720, after he had taken the position as rector. Hanna may have been the daughter of Whitemarsh's original vestryman. There is a haunting legend about Hanna Maynadier that tells of her becoming ill and dying shortly afterward. She was buried in the churchyard of Whitemarsh. She had a dying wish to be buried with her favorite ring placed on her finger. The ring was quite valuable, and two strangers who attended the funeral heard about the rector's wife being buried with the ring. They decided to rob the grave that evening. The two fiends snuck into the cemetery after nightfall and exhumed Hanna's body. They found the ring on

her finger but couldn't pry it off. They decided to cut the finger off of Hanna's body. One of the thieves pulled a knife and began to sever the ring finger.

Surprisingly, Mrs. Maynadier was not dead but in a coma. The pain of the knife slicing into her finger caused her to awaken with a shriek. She sat straight up in her coffin. The thieves were so frightened at seeing Mrs. Maynadier "rise from the dead" that they immediately abandoned their "grave robbing" endeavor and bolted from the scene in horror and disbelief. Hanna Maynadier, sick and feeble, managed to gather her shroud around her, exit the coffin and trek the one mile home, where her grieving husband was spending his first night alone without her. She made it to the front door of the rectory, where she offered a subtle knock with her bleeding hand. Then she collapsed at the door. Her husband found her and pulled her into the house. With great care, he saw that she received medical attention, and he nursed her back to health. It is said that Hanna Maynadier lived for many years after the incident and even bore several children, but the bloodstain from her hand could never be removed and is still visible on the door against which she fell. Some believe that Hanna can still be seen, wandering around the cemetery with her shroud about her, looking for the way home. Today, husband and wife Daniel and Hanna Maynadier lie eternally side by side in a shared grave beneath the chancel of Whitemarsh Church. A commemorative slab marks the site.

When I was researching this book, I decided to visit the Whitemarsh ruins and see for myself whether they were haunted or had evidence of paranormal sensitivities. I am no authority on this, but when approaching a site, I prefer to be quiet and listen for "signs." Is anything abnormal or out of place? Do I get a strange feeling, a sense of peacefulness or a sense of foreboding? I entered with my car at the far end of the cemetery, drove past the rear of the church ruins and parked. I approached the church from the west side (the side bordering Route 50). I was amazed

at how many new graves are in this cemetery. Later, I discovered that this is an active cemetery for a church in Trappe. I decided that I would enter the ruined church through what used to be the front entrance. As I approached the side of the church, I noticed the marker and tribute to Robert Morris, which I read aloud into my digital tape recorder (I use this for research notes while at locations). The wind kicked up so furiously that I couldn't record my voice. I turned the recorder off. The wind died down so I began again. Again, the wind rose so furiously that I couldn't record. I decided to photograph the marker instead. When I lifted my camera, the wind started to blow again and blew so hard that I couldn't balance the camera to take the photo. I gave up. The wind died down again.

I walked to the front of the church and stood on the walkway between the boxwoods. As I approached, the wind picked up again. There are mature trees nearby, so the rustle of leaves was quite loud, but through the rushing wind and the sound of the trees I could hear a tiny ringing in the distance—a tinkling like a bell. I surveyed the cemetery and couldn't identify the source of the ringing. I began to walk up to the church, and again, a huge rush of wind nearly knocked me down. I could hear the ringing, quite soft, but definite. I looked again at my surroundings and saw a grave at the very western edge of the cemetery with a tiny wind chime placed on it. It was from this wind chime, with its one tiny bell, that the ringing sound originated. I noticed that there were many wind chimes on graves throughout the cemetery, all of them larger than this wind chime, yet they weren't ringing in this ferocious wind. I entered the church, and the foundation was still intact. The marker for the Maynadiers is prominent. I paused and surveyed the ruins and their surroundings, thinking, "This is a thin place, where the veil between this world and the next is transparent."

The grave with the tiny wind chime was relatively new, and it was the grave of a child. I decided that I would investigate a little

about Robert Morris Sr., since I was unable to take notes on his burial spot or photograph his grave marker. It turns out that he had a home in Oxford and was a prominent member of the community. He met his untimely death with irony. He was a resident agent for the Liverpool firm of Foster, Cunliffe and Sons. He had become quite a wealthy businessman through foreign trade, with strong local and international connections. A business associate of Robert Morris Sr. described the circumstances of his death:

> *A ship had arrived from Liverpool and, as was customary, Mr. Morris went on board. On his return to shore he was accompanied by the captain of the ship. This officer, before disembarking, had left orders for the firing of a salute, the signal for which he was to give by putting his finger to his nose. Soon after leaving the ship, a fly alighted upon the captain's nose and he brushed it away with his hand. On board this was mistaken for the signal to fire. The wad from one of the guns struck Mr. Morris in the arm. The infection from this wound resulted in his premature death. This was around 1750.*

His son, Robert Morris Jr., became a member of the Continental Congress in 1775 and was a signer of the Declaration of Independence. He financed much of the Revolutionary War with his own funds and became a close friend of George Washington. But his life came to an ironic end, like his father's, when, in 1798, income from his properties slowed and forced him into bankruptcy. He was thrown into a debtor's prison until 1801. It is said that Congress passed the bankruptcy laws, in part, to get Morris out of prison. Robert Morris Jr. died a poor man in 1806 at the age of seventy-two.

Robert Jr. died and is buried in Philadelphia. But his father, who came from Liverpool, England, and settled in Oxford, is buried at Whitemarsh. His new marker reads:

IN MEMORY
Of
ROBERT MORRIS
Native of Liverpool in Great Britain
Late merchant at Oxford.
Punctuality and Fidelity influenced his dealings.
Principle and honesty governed his actions
with an uncommon degree of sincerity.
He despised art and dissimulation.
His friendship was Firm, Candid and Valuable.
His charity Free, Discrete and Well Adapted.
His zeal for the public was active and useful.
His hospitality was enhanced by his conversation
with cheerful wit and sound judgment.
A salute from the cannon of a ship, the wad
fracturing his arm, was the means by which he
departed on the 12th day of July, MDCCL.

THE WILDERNESS

Trappe, Talbot County

I t was once said that if you positioned a boat in the middle of the Choptank River, just across from Clora's Point, you could see the homes of seven governors of Maryland. The home that is on the highest ground in this section of the Choptank's north coastline is the Wilderness, also referred to as High Banks. The original part of the home was built in 1785, and Daniel Martin inherited the property upon his father's death in 1808. Daniel, who married Mary Clare McCubbin of Annapolis in 1816, was a colonel, commanding part of the state militia, and a member of the Maryland House of Delegates from 1813 to 1820. He served as Maryland's twentieth governor from 1828 until his death in 1831.

In 1815, Daniel Martin added a large wing in the Federal style to the Wilderness. He was proud of his waterfront home. He is quoted as saying that from the highest bluff at the Wilderness one can take in "views of unrivaled beauty in this country." The Wilderness has been known for years to be haunted. Even members of the family that has owned it for quite some time have admitted to friends and close acquaintances that strange, unnerving experiences have occurred there. It seems that in the mid-nineteenth century, an unnamed proprietor of the Wilderness was out surveying his other farms. When he returned home, he found his wife dead. She had died

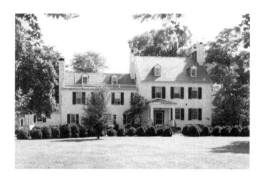

The Wilderness, home of the Kissing Ghost. *Courtesy of the Maryland Historical Trust.*

suddenly in his absence. Theirs was a strong marriage, rich with love and affection, and the wife's sudden death did not permit any final goodbyes. The wife is said to haunt the place, and men who sleep in the room where her husband used to lie will be awakened by the soft kiss of a beautiful woman. She is known as the Kissing Ghost.

A local who has spent his whole life in Trappe told me that his aunts used to visit the children who lived at the Wilderness, and there were certain rooms upstairs that were off limits. Once, his aunt observed a rocking chair rocking all on its own in one of those rooms. In more recent years, an adult daughter of the family who owned the Wilderness came to visit her parents and slept in the same room known to be occupied by the Kissing Ghost. Instead of being awakened by a kiss, she was startled and frightened out of her sleep by a man who hovered over the bed. He placed the rocking chair on top of her in the bed. She ran from the room and later described the ghostly man to a caretaker who had been on the property for years. The caretaker said her description fit the previous owner, who was then deceased.

The Wilderness is a private home and is not open to the public.

> *The old plantation graveyards the owners passed away,*
> *The waving wheat and silking corn in our ancestral day,*
> *And the tread of strangers, where low the coast wind moans,*
> *The plowshare grating ruthlessly above dishonored bones.*
> —*excerpt from Dr. L.P. Bowen's "Makemieland"*

THE TUNIS MILLS HANGING TREE

Talbot County

There is a tree in the Tunis Mills area known as "the hanging tree" due to its abnormal shape. The locals tell that it is believed that slaves were hanged from this tree or that it was the site of lynchings. Area residents tell of a legend that says when you sit under the tree with your car off, you will begin to hear and see the dead. It has been reported that some hear the bodies drop onto the car from the horizontal branch of the tree. True or false, the lore of the Tunis Mills hanging tree is a favorite of ghost hunters and those intrigued by hauntings.

When I first heard of the hanging tree, I had only one piece of information about it: it was in Tunis Mills and was believed to have been a tree where slaves were hanged. I had seen a grainy photo of the tree on the Internet but had no specific location or directions about how to find the tree. Tunis Mills is a small community with only a few roads. I figured that if I drove down all of the roads and looked carefully, I would eventually find the tree.

No such luck! I drove for over forty minutes, up and down the roads of Tunis Mills, carefully scanning the roadside for a tree that looked like a street with a one-block dogleg. Finally, I gave up and pulled out my iPhone. I Googled "hanging tree Tunis Mills" and not only found the location of the tree but also an Internet forum

The hanging tree, Tunis Mills.

with an open discussion of people who had visited the tree and tried the experiment of turning off the engine and listening for the eerie death sounds. The following are some of the entries:

If anything it is VERY creepy. Even during the day. You will hear noises if you sit at night with your car off. Things hitting your car too.

I went to this tonight. me and my friends sat in the back of his truck and I climbed up on the hood and grabbed on to the tree. Nothing happened. I was disappointed hah.

I was just there earlier today. No matter what time of day it is it just seems to be so dark. The woods are pretty thick to let much light in. I've been there and some scary stuff, but nothing happens when people are in the back of a truck or outside. You have to stay inside of a car or truck for it to work.

I've taken pictures there and had some things come up that were beyond weird. I love it so much!

I have been there a couple of yrs back. I started to hear people whispering but I could not hear what they were saying. Very creepy down there in the middle of the night.

I went there one night. My car started shaking back and forth at the stroke of midnight. After cleaning my britches I vowed never to return again...

So I ventured out to find the tree. It was on a road that was just before Tunis Mills. I turned off, and as I approached the Miles River, a bald eagle flew right in front of my car, nearly hitting my windshield. It startled me, and I slowed down, trying to see where the bird went. I grabbed my camera, hoping to get a shot of him. He vanished, and I continued slowly down the road, scanning the sides of the road. It was dusk, and the road became secluded. I lost much of the daylight as it was blocked by thick groves of trees on both sides of the winding road. I came around a short bend and

there it was! No need to scan the roadside to see this tree; it jumps out at you. It is creepy and strangely shaped. I stopped, got out of my car and shot dozens of photos, but I felt like I couldn't leave. While the tree was creepy, it was intriguing. I decided to do the experiment mentioned in the Internet forums. Feeling somewhat foolish, I pulled my car directly under the tree, came to a stop, put the car in park and shut off the motor. Immediately, I heard a piercing vibration of sounds—*rat-tat-tat-tat-tat-tat*. I was scared to death. The sounds started as soon as I shut the engine off. My fear took over my logic, and for an instant, I felt like bolting out of there. It was with great relief that I spied the red head of a downy woodpecker on the tree above me. How did he know to start pecking just as I turned off the car?

The small community of Unionville is on the way to Tunis Mills. The Unionville AME Church and historic graveyard are on the right. In the cemetery, there are graves of African American Union soldiers and slaves from nearby plantations—lots of ghosts there!

SHOAL CREEK MANOR

Cambridge, Dorchester County

Today, there is nothing left of Shoal Creek Manor, the home of John Woolford and Governor Charles Goldsborough. This plantation house was built about 1750 and once stood on nearly four hundred acres in East Cambridge. Originally, it was part of the Choptank Indian lands and was purchased from the Indians by the Ennalls family. Many tales are associated with Shoal Creek Manor; tales that are still told today, even though the building was razed in 1970 to make room for a new wastewater treatment plant. The folklore collection at the Nabb Center in Salisbury University had the following transcripts of tales told by locals about Shoal Creek Manor.

From Shirley Brannock (age forty-five) of Cambridge as told to student Virgina Meekins:

> *Shoal Creek Manor was known only as "The Haunted House." Patty Cannon used it as a place to keep her slaves and she chained them to the walls in the cellar. You could go in the house at night and hear the chains rattling as the slaves were trying to escape. Manacles and chains were found in the basement and even now people hear the chains rattling.*

From William H. Moore (age sixty-five) of Cambridge as told to student Virginia Meekins:

> *Shoal Creek Manor was always "The Haunted House." When the boys would go in there at night, you could hear people talking upstairs, although no one lived there. It was said that a former governor, Charles Goldsborough, had lived there and it was he and his wife that you could hear talking together.*

From Fred Boog (age seventy-eight) of Vienna as told to student Connie Moore:

> *One of the stories about ghosts haunting the house begins with the sinking of a boat in the Choptank River during a storm. The captain of the boat swam to the beach near a manor. The manor is known as Shoal Creek Manor, a house of 16 rooms and the ground floor ceilings were 12 feet high. Fireplaces were the only means of heat. In the attic were openings to two rectangular shafts leading all the way to the basement—secret passages.*
>
> *The captain of the boat swam to the manor's beach, dragging his valuables behind him. Staggering to the deserted building, he buried his treasure in the cellar and then died. Many diggers have sought the treasure without success. However, the chains which once pinioned slaves in the dark dungeon-like cellar reportedly were torn from the walls and carried away. People of the area have reported through the years to hear the rattling of chains and weird scratching sounds at night.*

From Allen Dennis (age forty-eight) of Cambridge as told to Cathy Wright:

> *The house is known as the Shoal Creek Manor because it is on the Shoal Creek in East Cambridge. It was where the run-away slaves used the Underground Railroad to smuggle slaves*

out of the South. The house was empty for years and years when I was a kid. They called it the Haunted House because the leaders wanted to keep people from snooping. They would rattle chains and say that slaves were hidden between the walls in the basement. I remember as a kid, that the walls were real thick. Chains were on the walls of the basement.

From Mrs. William H. Dail Sr. (in her late sixties) of Cambridge as told to K. Jeannette Robbins:

The old house at Shoal Creek that they just tore down, was haunted. They said you could hear chains rattle in it and they claim there was a pump outside and the handle would go up and down when no one was near it. There were chains in the cellar of the house, where they used to bring slaves in the "dead hours of the night" and keep them there until they were sold. The man who sold the slaves buried his money in the yard instead of putting it in the bank, and the chains rattled because the slaves were trying to tell where the money was. Someone finally found the money and then no one ever heard the chains anymore because the slaves were satisfied.

SUICIDE BRIDGE

Secretary, Dorchester County

Suicide Bridge is a two-lane automobile bridge that crosses Cabin Creek just north of the villages of Secretary and East New Market in Dorchester County. The locals say that there has been a bridge for vehicles crossing this spot on Cabin Creek since 1888. The original one-lane bridge was made of wood and was primarily used for local village traffic. By 1967, with the proliferation of heavy automobiles and farm equipment, a new two-lane wooden bridge was erected and covered with asphalt.

It doesn't make sense that this bridge would be called "Suicide Bridge" because it is low to the ground and the water isn't deep. Some say that at low tide a person could leap from the bridge and then stand up in the water. But tradition says that there were several people who committed suicide from this bridge; hence, the locals began to refer to it as Suicide Bridge. The name has stuck.

Due to heavy use, a completely rebuilt bridge was put in place in 2005. Today, the bridge gets a good amount of local automobile traffic, partially due to a popular waterfront restaurant—Suicide Bridge Restaurant—located at the south crossing. The restaurant has become a destination for locals throughout the Shore, renowned for excellent seafood, steak and paddle-boat cruises, making this grimly named spot on Cabin Creek even more famous throughout the region.

The only place where I was able to find historical information on how the bridge got its name was at Suicide Bridge Restaurant. It has the legend printed on its menu. The same information is repeated on its website:

The first victim of Suicide Bridge was a postmaster from Hurlock, who shot himself and then fell into the water of Cabin Creek. The second victim was a farmer, who also shot himself and fell into the swirling waters of Dorchester County Creek. Next was a man who some say willfully dove off the bridge, while others say he met with foul play. Pete Moxey, a lifelong resident of the area, was eight or nine years old when it happened.

"It's the first one I remember. A fellow they called 'Frog.' He was black, short and stocky. They claimed he jumped off the bridge and hit his head on the piling. But the word was going around there was foul play in it. I don't know," sixty-year-old Mr. Moxey said. He remembers that once the body was found, "they put him on a table over there in a picnic area and did an autopsy, right out in the open." Mr. Moxey, however, was sent home before the autopsy was performed.

Mr. Moxey said he was surprised at how quickly another suicide occurred after the third bridge was built. "It was up for six months, then bingo, somebody went off," he said. "I helped pull that guy out of the water…He had been a longtime employee at Continental Can in Hurlock and was just coming off a long vacation…Instead of going back to work, he drove here, parked his car and jumped off the bridge."

After rescuers located the body, Mr. Moxey said, the ropes got tangled and he got in his boat to help bring the body out. The body was placed on the dock. "The blood soaked into the wood on the dock and it never washed away," said Mr. Moxey. "It was there for about five years. I tore it down and built another."

Another man, born and raised within a half mile of the bridge, moved away for many years, came back, parked his car by the foot of the bridge and shot himself. "I don't think the bridge is jinxed. Maybe it's just the name that brings them here," Mr. Moxey said of the suicides.

In a more recent incident, Dave Nickerson, who at the time lived across the creek next to the bridge, was awakened one morning by calls of "Help...Help!" Seeing a car parked on the bridge, he immediately jumped into his skiff and zoomed to where calls were coming from. He pulled a woman from the icy water, where she had apparently changed her mind about committing suicide. Nickerson immediately took her ashore, ran to her car, which was running, and drove to the skiff. When he tried to get the woman into the warm car, she replied, "I don't want to get the seats wets—it's a new car!"

PATTY CANNON'S
TRAIL OF TEARS

Dorchester County

I n the small town of Reliance, at the crossroads of Routes 392 and
577, three counties and two states come together within a radius
of a few miles. The town used to be called Johnson's Crossroads
after a tavern that was located at this intersection. Today, a house
stands here with a wayside marker that reads:

> *PATTY CANNON'S HOUSE*
> *at Johnson's Crossroads*
> *where the noted kidnapping group had*
> *headquarters as described in*
> *George Alfred Townsend's novel*
> *"The Entailed Hat." The house*
> *borders on Caroline and Dorchester Counties and the*
> *State of Delaware.*

There are many who argue that the house is not the original
Patty Cannon House, but no matter. Her house was either on that
location or very nearby. This marker defines where the gang had
its base and where it imprisoned, tortured and murdered scores of
innocent people. In truth, Patty Cannon was nothing more than a
female thug who led a gang of criminals. She was famous for being

a kidnapper and slave catcher, but her great talent was making a profit off victimizing the weak.

Her background is sketchy, but it is believed that she was born in Canada. Her father was hanged as a criminal. Patty met and married Jesse Cannon of Delaware in 1790 and moved to the Seaford area, settling on property that spanned Dorchester, Caroline and Sussex Counties. Jesse Cannon's family was large in the Seaford area and also operated Cannon Ferry (now called Woodland Ferry), which transported people and goods down the Nanticoke River. Patty's daughter was married to Joe Johnson (her first husband was hanged). Joe Johnson became Patty's partner in crime. They ran a gang that included Patty's husband, Jesse, her daughter and other white criminals. The gang also included several blacks who would act as decoys to lure blacks and whites into the gang's lair. They would catch or kidnap slaves and free blacks and then sell them to slave traders for a profit. Occasionally, gang members would rob and murder travelers who had few personal ties or kill those who obstructed their fiendish practices.

In 1808, Congress passed a law prohibiting the importation of slaves into the country. Supply of new slaves to work on plantations grew slim, and the demand for slave farm labor increased. Delaware was the only state that had any type of punishment for slave dealing/trading. All other states turned a blind eye, except when a slave was stolen from a white owner. Patty's operation was similar to the Underground Railroad, but in reverse. Her gang used the same dark swamps and rivers to transport people, but they were sending prisoners deeper into the South to be sold as slaves instead of liberating slaves and shipping them north to freedom. All of this was done undercover, and those who knew about it didn't discuss it openly. Like any mob family, Patty's gang was feared. The gang capitalized on this fear.

Few documents exist about Patty and her slave-catching, murderous history. Most of what has been written was sensationalized and exaggerated to sell books and newspapers,

similar to today's tabloids. The best biographer of Patty Cannon—one who has a balanced presentation of her life based on facts—is Hal Roth, who wrote *Patty Cannon, The Monster's Handsome Face*.

In 1826, authorities in Delaware arrested Joe Johnson for suspected slave trading. They found ten people chained in his attic, including free blacks and slaves. Small children were among this group of hostages. Joe Johnson was severely punished (lashed, with ears nailed to a post), and shortly afterward he took off for Florida, selling his tavern and property to his sixty-something mother-in-law, Patty Cannon. Approximately two years later, a farmer dug up human bones in a field previously farmed by Patty. Authorities jumped at the opportunity to finally charge her with something that would stick. The sheriff acquired incriminating information from one of Patty's trusted slaves, who told the authorities where three more bodies were buried, one of which was an infant.

Law enforcement from all three counties teamed up to arrest Patty. She had formerly eluded arrest by going to a different jurisdiction on her property when pursued by one county sheriff at a time. They agreed to let Sussex County, Delaware, take Patty in and levy the charges of murder. She was arrested for the murder of four people and imprisoned in Georgetown, Delaware. On May 11, 1829, Patty was found dead in her cell before she ever had to face the hangman's noose for her crimes. The traditional belief is that Patty hid poison in the hem of her skirt and ingested it before having to face execution.

Patty Cannon was buried with two others in the jail yard. Years later, their bodies were exhumed and reburied in a potter's field nearby. Somehow in this process, Sussex County deputy sheriff James Marsh took possession of Patty Cannon's skull. In 1907, Marsh contracted tuberculosis and moved to Colorado, leaving the skull with his brother, Charles. For thirty years, the skull hung on a nail in Charles's barn and became quite a local curiosity. Finally, to save it from damage or theft, Charles put the skull in a box and

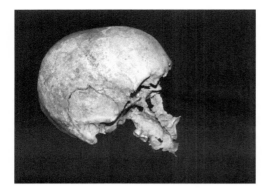

The skull of Patty Cannon, now kept at the Dover Public Library in Dover Delaware.

stored it in his attic. He died in 1946, and his son, Alfred, took possession of the skull. In 1961, Alfred loaned Patty Cannon's skull to the Dover Public Library, where it is still stored today.

I made an inquiry to the director of the Dover Public Library about seeing Patty Cannon's skull. While the library does not display the skull publicly, the director allowed me to come in, view the skull and interview her about its provenance. About 180 years after Patty Cannon's death, her skull is stored neatly in a small, square train case in a private, locked room in the library. It is well packed and also has a series of documents that show how it got from a grave in the Sussex jail to the Dover Library. The jaw bone and lower teeth are gone, and part of the face is decayed. Ever so subtly, the name Patty Cannon is written in pencil across the top of the skull. I photographed the artifact and held it for a few minutes, fully taking in the moment of having the skull of Patty Cannon in my hands. It is morbid and sad to have a skull separated from a body and stored on the shelf in a secret room of a public library. Many believe that Patty's soul can't rest because of that.

The town's people changed the name in order to shake their association with Joe Johnson, Patty Cannon and her gang. Ghost hunters and paranormal experts find the fields around Reliance full of orbs and strange lights and noises. It is one of the most "hunted" ghost sites on the Eastern Shore.

GREEN BRIAR SWAMP AND BIG LIZZ

Dorchester County

I f you ever ask anyone to tell you a ghost story about Dorchester County, the first one mentioned is usually the tale of Big Lizz and the Green Briar Swamp. The story has been around since the Civil War. Green Briar swamp is about ten square miles and is located near the Blackwater Wildlife Refuge. Most of lower Dorchester is swampy, with endless vistas of marshland, but scattered across the area are farms. Years ago, these were thriving plantations operated by slave labor. In fact, Harriet Tubman worked on a plantation near Green Briar Swamp and began her Underground Railroad in this vicinity.

The Eastern Shore didn't see much action during the Civil War. There were no battles here, no famous camps or sites of conflict; but there were many plantations and many slaves. Therefore, much was at risk for local farmers and merchants if the Union won the war and slavery was abolished. The Shore was a popular trafficking area for smuggling supplies out of the North to the Confederate troops in the South. It is believed that while Eastern Shore plantation owners and businessmen were involved in smuggling supplies to the South, the Eastern Shore slaves were involved in spying on those smugglers and reporting their actions to the North. For a time, Harriet Tubman served as a scout for the Union army.

The Green Briar Swamp region in lower Dorchester County.

The legend states that Big Lizz, a very large—almost giant—plantation slave, was a spy for the North. Her master was a smuggler. Her master discovered that Lizz was a spy and was appalled, because Big Lizz was one of his most trusted slaves. He told Big Lizz that he needed help with hiding some money. Together, they went out into the swamp, where Lizz dug a hole for his treasure. Once she buried the treasure, the master drew his sword and, with one swift motion, cut off Big Lizz's head. He left her there in the swamp. Shortly after this, his life began to crumble. He lost his money, his health and his family. He never went back for the treasure and died a broken man. Then people began seeing strange lights in the swamp. Some who investigated and went into the swamp never returned. People reported seeing Big Lizz coming out of the swamp near where the DeCoursey Bridge is today. They saw her holding her bloody head in her hand and calling, beckoning, encouraging those who saw her to follow.

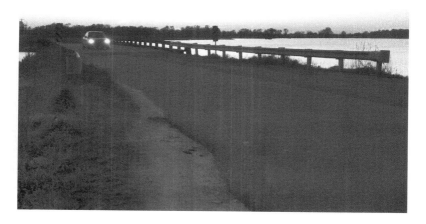

DeCoursey Bridge, where Big Lizz is said to meet those who signal to her.

Folks believed that she was coming out of the swamp to lead others to her master's treasure, but those who followed Big Lizz never came out of the swamp. Tales of headless bulls, wild men and monsters in the mist were all part of the stories linked to Big Lizz and those who met their demise after answering her call. The locals say that if you drive your car up to the DeCoursey Bridge at night, when it's completely dark, honk three times, flash your headlights twice and then turn off the car, your car won't start again. Big Lizz will emerge from the swamp, through the mist, with her head in her hand. She'll motion for you to follow. She'll lead you to the treasure, but follow at your own peril. No one has followed Big Lizz and come out of Green Briar Swamp alive.

TALES FROM DOWN BELOW

Dorchester County

Lower Dorchester County is made up of several island chains and small communities tucked into rare pieces of high ground that are, in turn, tucked into the marshes. The terrain is wild, with low land, big sky and little to obstruct the wind that sweeps over the water and marshland. The area is undeveloped and looks much as it did when the first white colonists settled here over three hundred years ago. Some of the folks who live "Down Below," as the area is called by the rest of Dorchester County, can trace their ancestors back fourteen generations in the same community.

Every square mile of this region is teeming with wildlife that includes foxes, squirrels, muskrats, otters, bald eagles, great blue herons and deer. Blue crab, fish and oysters are brought out of the waters to be processed in the smattering of seafood packinghouses that still operate on the shores of this region. Mosquitoes and green-headed flies keep the outsiders at bay, as methods for living with and combating these pestilences are bred only into the natives of lower Dorchester. It is hot and humid in the summer, and the frigid winter wind could stop the beating heart of an inland dweller. It is wild country, but the region ranks as one of the most scenic and unspoiled landscapes in America. For generations, people who live Down Below have made their livings on the water,

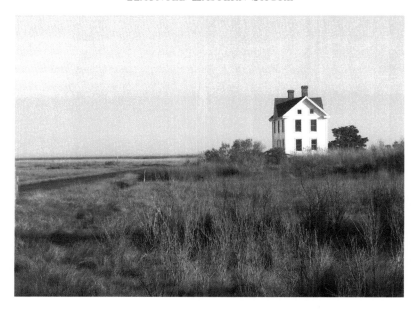

Bishops Head, Dorchester County.

either as watermen, seafood processors, boat builders/repairers or providers of other support services for watermen. All of these circumstances have helped to develop the tightknit communities of this region that include Hooper Island, Taylor's Island, Bishop's Head, Crocheron, Cokeland, Golden Hill, Fishing Creek, Wingate, Toddville and others.

In 1970–72, folklore students from Salisbury University went into lower Dorchester and interviewed residents. They asked about legends, tales, ghost stories, traditions and rural living practices. These interviews are now housed in the Nabb Research Center on the Salisbury campus. I extracted several narratives that dealt specifically with ghosts or hauntings in the region. They are printed here just as the informant dictated, with little editing. The stories below weave an interesting tale that offers a glimpse of the private communities Down Below.

Ghostly Tales from East of the Chesapeake

From Gloria McWilliams (age twenty-four) of Fishing Creek, September 18, 1971. Gloria lived on Hooper Island most of her life:

Our milkman, Ham Phillips, said that one morning while he was making deliveries, he saw a woman dressed in all white by the Blackwater Bridge. He approached the woman and asked her if she wanted a ride; she did not answer so he left. As he pulled away he noticed the woman was running alongside of his truck. He kept on going and the woman was still running beside him. She followed him to the bridge at Great Marsh (approximately 8 miles). When she got to the Great Marsh Bridge, she jumped over. Mr. Phillips kept on going and the lady was never seen again. Even today at Hooper Island the story is still being told. People say that this happened about seven years ago.

From Lilly Todd of Cambridge (born in Golden Hill), November 1971:

A long time ago, a distant relative of mine was bitten by a rabid dog and had later developed rabies. At this time there were no hospitals or medications, so this relative of mine had to be cared for at home. They kept him in a locked room and fed him through a hole in the door. His condition got so bad that at times he would be found gnawing flesh out of his own body. Not long afterwards he died and was buried in Golden Hill Cemetery. To this day at times his jawbone still comes to the surface of the grave. This might sound a little far-fetched but I've seen this myself.

My husband told me another story about Slaughter Creek Bridge at Golden Hill. On foggy nights a woman of some sort is suppose to come out of the water and call to travelers to follow her. After she calls to these people, she goes back over the bridge and vanishes in the water.

From William Gootee Jr. (age twenty-five) of Golden Hill, November 10, 1972:

I know of a haunted house that you wouldn't believe. It is located at the foot of Great Marsh Bridge, near Hooper Island. The house used to belong to the Spicers. I've been inside the old place and that is the weirdest place! You can be just standing in the hallway and all of a sudden this howling and whistling and clanging starts. It's almost impossible to trace the location of this as it seems to be coming from every direction. Needless to tell, not too many people care to look for the source either.

It's been said that if your car breaks down in the vicinity of the Catholic Church (about 6 miles from Gootee's Marina going towards Hooper Island) that while you're fixing your car, for instance changing a tire, you can feel something like a lady's breath on your neck.

Some have actually seen a figure like a woman's form, but whatever it was, there have been some awfully strange tales from this area. This form or whatever will not disappear until you have gotten the car fixed. Whatever it is, if my car ever breaks down there, I'm going to just leave it there, take the keys and run!

From Lorraine Jones (age thirty) of Taylor's Island:

I used to hear my great aunt and mom talk of places on Taylor's Island where money and riches were buried. One evening as they were gathering, locating and cutting down dead trees and the like for fire wood, a treasurer-like box, very shiny and silvery, appeared from under one of the tree roots of an old dead tree that had been pushed over. To get a better look at the box and its contents, they decided to dig it all the way up. My Uncle Russell (Dad's brother) brought them the spade from the trailer on which they were to carry the wood. So with spade in hand,

Dad attempted to dig the box all the way up. Just as the shiny box was almost at a point where they could grasp and remove it, Uncle Harvey yelled, "We've got it!" At that very instant, the shiny box was mysteriously engulfed by the soil of the earth and disappeared from sight. Dad started to dig for it again right away. He dug and dug only to find nothing. The box had somehow disappeared completely. Shortly after that, Mom said the winds suddenly started to blow for no apparent reason as the sky was completely clear.

A few months later Mom recalled a saying, "If one should ever sight a buried treasure, never say a word, claim the treasure and leave. For one spoken word out loud about the treasure, it will leave and be lost forever."

Folks back then often resorted to burying their valuables such as money, jewelry and the like as a means of safekeeping as opposed to keeping it in a bank. Using those means of safekeeping (burying) probably made sense considering that the nearest bank was located some 18-20 miles away in Cambridge. Not everyone was fortunate enough to have an automobile.

From Vernon Lowe of Cambridge, recalling a story told to him by Marcellus Hurley (who saw the ghost), November 1971:

Ghost Island is located in Cokeland (5 miles south of Vienna). It is mostly brush and marshland stretching its entire length. The old Lewis house owned by the late Levin Lewis, is in this area too. The story goes that Lewis was a wealthy man, mainly from his shady business deals during the American Revolution. In order to protect his wealth from American soldiers, he has been hiding his riches on Ghost Island all these years. Marcellus Hurley saw the ghost one night as he was paddling down the river in his small boat. He saw a figure carrying a box of some sort walking in the grass. This thing came to the edge of the water and stepped on the top (not in) and walked across to Ghost

A house in the Wingate area of lower Dorchester.

Island. His face had no expression and his eyes were closed. This was at least two or three years ago. I don't know if the face has been seen since.

From Diana McClain (age twenty-two) of Cambridge, October 18, 1971:

At Bishop's Head it is said that an old woman used to rock and sing to her children before she sent them to bed at night. Bob would walk by her house sometimes when she was doing this. Then the old woman died.

One day, Jimmy Bramble walked by the house and saw her ghost sitting on the porch. The rocking chair was rocking and he could hear hymns being sung from inside the house. As he walked by a nearby graveyard, he saw a lantern moving so he hid in order to see who was carrying the lantern. When the lantern

went past him, he could see that no one was holding it and he ran away.

From G. Lake Wilson (age fifty-three) of Cabin Creek, August 2, 1970:

In Crocheron, a homeboy (an orphan boy taken by farm people to raise) ran away from home because he was receiving bad treatment. He could be found nowhere. About a year after he disappeared, they said a dark-haired and dark-skinned boy would come and stay with the marsh cows at nights. He got his food by stealing cow's milk and he slept next to the cows at nights. He wore potato sacks instead of regular clothes. He was so sneaky that no one could get up with him. They didn't realize it was the homeboy.

Finally, one clever person caught the cowman. He had been away from people so long, he could only grunt. He was extremely shy and hid behind trees. His hair was extremely long. In fact, he didn't seem like a person at all. After this, everyone called him the "Wildman." They saw him only rarely in the evenings. He soon began to have quite a reputation in the Hooper Island area and he was the main character in many tales. The cowman was later put in a state hospital.

THE GHOST LIGHT ROAD

Hebron, Wicomico County

There is a road off Route 50 between Hebron and Mardella Springs—formerly called "Old Railroad" Road—that was known for having phantom lights appear to travelers who ventured down the road. No one has been able to trace when these light began appearing, but local recollections go back as far as the mid-1800s. The road was once paved with oyster shells, and those traveling south toward the village of Quantico reported seeing strange lights. This was before electricity, and many people thought that someone was carrying a lantern or a torch. Numerous locals over the years saw the lights in the thick, wooded area lining the roadbed. So many people reported seeing the lights on "Ghost Light Road," as it became known, that the government brought in scientists to investigate. Their theory: swamp gas. A gas created in the swamp caused the illusion of light. The only problem with this theory was that the area where the lights were seen was not swampy.

Several theories developed among the locals about the origins of the phantom lights.

In 1971, William Dorman of Berlin said:

> *Many years ago, when a railroad lightsman would walk out on the track and wave a lantern when the train came along, one of*

them got killed. They say that the light that shines there every once in awhile is the ghost of that man who got killed. One night I was riding around with a State Trooper, and we saw the light. So we tracked down the spot where we had seen the light glowing, but there wasn't a thing there.

In 1970, Mary Twilley of Delmar said:

Long ago, an argument was going on as to where to build the new railroad which was to go through Hebron. One particular engineer wanted the tracks to be laid where the Ghost Light Road is today. Instead of laying tracks there, a county road was built instead. It is said that the ghost of this engineer with his ghostly train comes down the Ghost Light Road once in awhile. The strange light often seen there is the light in the front of his ghostly engine.

Mary Twilley also gave the following explanation, which is commonly repeated by others:

It is said if young children are naughty and do not take their medicine, something terrible will happen to them. There is an old woman who brings her rocking chair out in the middle of the road. She sits her lantern beside it. Leaving her chair, she goes to find bad children who fuss when asked to take their medicine. If she finds any, she takes them away with her. It is said that the light often seen on Ghost Light Road is the old woman's lantern as she walks along, looking for children who will not take their medicine.

Once the road was paved with asphalt, the light sightings stopped, but the tales live on. The tale of the Ghost Light Road in Hebron is one of the most commonly told stories about paranormal activity on the Eastern Shore.

THE CELLAR HOUSE

Worcester County

In 1760, a wealthy merchant, William Allen, built a plantation house on a tract of land along the Pocomoke River. The plantation is located between Pocomoke City and Snow Hill, both strong port towns in the eighteenth and nineteenth centuries. Mr. Allen not only ran the plantation, but he also owned and managed a fleet of ships that traded in the Caribbean. He died in 1792, and the property eventually passed to his heirs and acquired the name Cellar House.

The Cellar House has a long legacy of being haunted by a young woman and her baby, who met an untimely death in the Pocomoke River. The Pocomoke River itself is quite haunting, as most of it is bordered by thick forest. Trees include the great bald cypress, with its wobbly knees, which protrudes through the swampy shores and leaks blackness into the coffee-colored river. The Pocomoke has swampy ridges and is the deepest river for its width in Maryland. Back when the river was plied by schooners that brought imported goods to the port towns, stories surfaced that the Cellar House had tunnels that were used for smuggling goods from the riverbank to the cellar of the plantation house. One particular legend states that the house was built by a six-fingered sea captain as a wedding present to his bride. He often travelled for long periods. He returned

The Cellar House on the Pocomoke River. *Courtesy of the Worcester County Library.*

home unexpectedly one day and found his wife pregnant, obviously by another man. Enraged, he banished her from the house and told her never to return. Meanwhile, he continued to smuggle loot from ships at sea and distant ports, transporting it through a system of tunnels and stashing it on his property or in his cellar.

The wife lived in another village, but after giving birth, she decided to return to her husband and beg for mercy. She was able to hire a raft, operated by an elderly man who agreed to transport her and her baby up the river to the Cellar House. The three of them set out one night, but on the way the raft overturned. The baby and the old man were drowned. The woman pulled herself to shore and continued walking until she reached the Cellar House. She found her husband and told him that the baby was lost; she begged him to take her back. A row ensued, and the six-fingered sea captain stabbed his wife to death.

It is said that cars parked in the woods near the Cellar House come out of the forest with a six-fingered handprint on them. This is the captain warning people to stay away from his hidden wealth.

Supposedly, the bloodstain on the floor where the murdered wife died has never been removed; even when new floorboards were installed, the stain resurfaced. People report a light seen and cries heard in the swamp near the Cellar House, particularly the cries of an infant and the wailing of a guilty mother. Some believe that the mother is carrying a lantern, looking for her lost child.

Today, the Cellar House has been beautifully restored by owners who purchased the property in 1987. At times, it is used for public events. It can still be seen by boaters who navigate their crafts up the Pocomoke. It looks much like it did in years past.

THE GHOST OF THE SNOW HILL INN

Snow Hill, Worcester County

The building known as the Snow Hill Inn on East Market Street in Snow Hill was built about 1835 for Levin Townsend, a prominent landowner and businessman. In the past, it has served as a private home, the town post office, the home of the town doctor, an apartment building, an inn, a Mexican restaurant and now a private residence. For the last twenty years, residents of the house, visitors, workmen and neighbors have repeatedly claimed that they experienced paranormal activity. Lights going off and on, windows closing by themselves, strange noises, candles lighting themselves, apparitions of a young man and fireplaces mysteriously lighting on their own are just some of the reported experiences.

Because the claims have been made for a consecutive number of years by people who have no association with one another, the Snow Hill Inn is widely accepted as haunted—but by what or whom?

Dr. John S. Aydelotte occupied the house in the 1870s and ran a medical practice in Snow Hill. He served as the town doctor into the twentieth century. One of Snow Hill's senior residents claimed that he remembered as a child seeing Dr. Aydelotte walking through the town streets with his cane in hand, angrily shooing away boisterous children. The old doctor died in 1929. He is buried in Whatcoat Cemetery, just a few blocks away from his former home. He rests

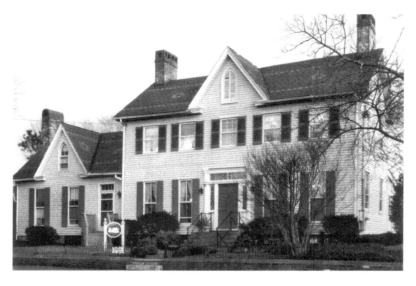

The Snow Hill Inn, home of John and William Aydelotte.

beside his wife, Delia, and son, William. Buried with him is a father's grief over a son lost tragically to suicide.

His son was William James Aydelotte, who, at the age of twenty-one, while attending the University of Maryland's School of Pharmacology in Baltimore, ended his own life by apparently "cutting his own throat several times," according to the *Baltimore Sun*. It seems that young William was not doing well in school, and the thought of his father's disapproval was evidently more than he could bear. Or maybe not—it all depends on what the evidence tells you. While in his room at a Baltimore boardinghouse, William penned a note, dated December 14, 1904, in which he wrote, "Dear Papa…it is useless to keep me at school." But the note was left unfinished. The next morning, the keeper of the boardinghouse discovered William after hearing deep groans and what sounded like someone falling. The following is an excerpt from a *Baltimore Sun* article printed the next day:

Hurrying upstairs, she opened the door and beheld the young man rolling on the floor, groaning and the blood flowing from several gashes across his throat...From the appearance of the room, Mr. Aydelotte had evidently cut his throat while standing in front of the bureau. He is then believed to have walked to his bed and cut his throat twice again.

Descendants of the Aydelottes have questioned the circumstances of young William's death.

Today, when someone is found dead or dying with a slashed throat, the death is generally investigated. Carefully gathered evidence is analyzed by a scope of highly trained professionals, each in varying fields, to determine "what really happened." But in 1904, the coroner, the police officer and the emergency-aid technician were most likely the same guy. We know from the news story that appeared in the *Baltimore Sun* the day after William was found dying that the case was closed and the obvious conclusion was drawn: suicide by slashing one's own throat twice or three times, depending on how one interprets the article.

The story in the newspaper was compiled in a single day with information from police, the coroner, the pharmacy school dean, the keeper of the rooming house on West Franklin Street and both the current and previous women in whose homes Mr. Aydelotte took his meals. The reporter details William—a third-year pharmacy student—developing tonsillitis and being too ill to study and Dr. Aydelotte writing to the dean, inquiring after William's progress. The same 1904 article also reveals information about a "young lady" in Westminster (Carroll County) with whom William had been corresponding, and the exchange was abruptly discontinued. Then the article hints that the friendship between William and his Westminster lady friend had recently been renewed. Speculation (even if unjustified) could cause a body to wonder what (or who) really drove William over the edge.

William's nephew, George Walton Mapp, whose mother was William's sister, was interviewed by a *Baltimore Sun* reporter in a follow-up article in 1993 about paranormal events occurring at William's childhood home—now the Snow Hill Inn. Mr. Mapp, a retired attorney, was seventy-seven at the time of the interview and described how he remembered his grandfather, Dr. Aydelotte, as being "a little cranky and opinionated." When asked about William's death, Mr. Mapp was quoted as saying, "We didn't talk about him. It was the great tragedy of our family. We never believed he killed himself."

Whether William did himself in out of fear of disappointing his father or "was done in" by someone who wanted him gone, many today believe that his unrestful spirit haunts the Snow Hill Inn.

In the early 1990s, the Aydelotte family home was purchased and renovated. The new owners converted it into the Snow Hill Inn—a restaurant with rooms for overnight guests. It was during this time that word spread fast about the innkeepers, contractors, guests, children, employees and towns people complaining of strange happenings, specifically stories of the young man who roams the halls of the inn, locking doors, opening windows, turning lights off and on, setting fire alarms, appearing in mirrors, shaking beds with sleeping guests in them, extinguishing candles, lighting the fireplaces and more.

Those innkeepers, not knowing the full history of the Aydelotte family that once lived there, dubbed their resident ghost "J.J." Eventually, the whole town began calling the inn's ghost J.J. Undoubtedly, the Snow Hill Inn has had more documented ghostly encounters than any other single site in Worcester County. The National Geographic Television Network featured the house in its *Is it Real?* series. As part of the preparation for filming, the network hired a medium to visit the inn and investigate its legendary ghost. The medium reported a strong presence and sensed that presence had an issue with its throat—choking or being strangled. (Or perhaps having its throat slashed three times?)

In 2003, the innkeeper was constantly disturbed by paranormal activity that included objects moving, banging, doors mysteriously being locked and candles lighting themselves. After the innkeeper was visited in the night by the ghost, who violently shook her bed, she asked a psychic who communicated with the spirit world to visit the inn and possibly help with quelling the activity. The psychic

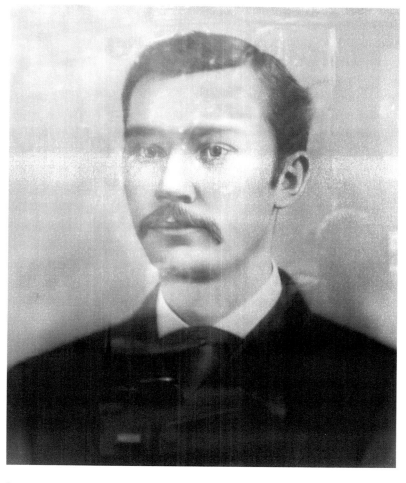

Photo believed to be of William J. Aydelotte. *Courtesy of Margaret Aydelotte Young.*

visited all of the rooms in the house and immediately affirmed that there was a disturbed spirit. The psychic felt the ghostly presence strongest in the Barrister Room, a small upstairs bedroom known as "the most haunted room in the inn." It was in the Barrister Room that the psychic spoke to the ghost, and, she claims, the ghost spoke back.

The psychic confirmed that the ghost was a young man: William Aydelotte. William told her that he did, in fact, commit suicide, and he shared details of a broken heart and secrets about an emotional trauma that the psychic said "were best left unshared." She did, however, state, "William had some serious issues that he has not yet resolved." She also told the innkeeper that he agreed not to bother her anymore. And he didn't.

I worked in the town of Snow Hill for a year and was amazed at how the haunting at the inn was commonly accepted as if it was no big deal. Everyone had a story—some told with laughter, some with awe and some with terror. I went to the inn once a week for lunch. I saw occasions when the gas-powered fireplace lit itself. I heard restaurant staff talk of being terrified at night when closing up. I myself saw lights go on by themselves and light switches mysteriously stop working while the light was on.

There is a kind of tragic sense about the place. It seems lonely, like it's waiting for the right family to come and call it home. Not since the Aydelottes left has there been one single family occupying it, calling it home. It has been rented and turned into several businesses. Today, it lies empty. Waiting.

ANANIAS CROCKETT'S HOUSE

Crisfield, Somerset County

The Victorian house on Main Street in Crisfield known as the Ananias Crockett House has a history of having a ghost. Ananias R. Crockett Sr. was born in Virginia in 1831 and married Sally Riggin of Crisfield. He built a home on the lot where the current house stands. It is believed that the original home burned down and the current house was built on the same lot by Ananias Crockett Jr., who had seen an identical house in Denver while on a business trip. Ananias Jr. ordered the plans for the Denver house and built one of the most ornate houses still standing in Crisfield. According to historical architect Paul Baker Touart, the Ananias Crockett House is "the most elaborate Queen Anne style dwelling to remain standing in the Bay-side town." The house was built about 1880 and showed off the Crockett's family wealth as seafood barons in the "Seafood Capital of the World."

The Crockett family partnered with the Riggin family, creating the Crockett and Riggin Seafood Company, which was the largest seafood-packing company in Crisfield. Later (according to Woodrow T. Wilson in *Crisfield Maryland 1676–1976*), Ananias Jr. was head of Tangier Packing Company, handling thousands of gallons of oysters each season with a sub plant in North Carolina. Ananias Jr. also served as the mayor of Crisfield from 1926 to 1930

The Ananias Crockett House in Crisfield.

and was in office during the great fire of 1928. He was also the director of the Bank of Crisfield.

The Nabb Center in Salisbury has oral testimony given in 1970 by Jay M. Tawes, of Salisbury, who states that he grew up in the house and that there were random strange occurrences four to six times a year. These would include footsteps in the attic and upstairs hall that would continue down the stairs, approaching the dining room. Often times, the sound would approach a room that the family was in and come right up to the closed door. But no one ever entered, the door never opened and, if the family investigated, no one could be seen. His family referred to the ghost as "old Ananias."

Mr. Tawes also tells a story about when it would rain:

> *Many times when it would rain, you could hear a choir singing.*
> *It seemed to come from the front part of the upstairs. After*

thoroughly searching we decided it was the rain on the tin roof of the porch. Except for one thing! Regardless of who would be there or how many people could hear the singing, all present could agree on what hymn was being sung. Everyone always heard the same song…old-fashioned hymns like "Old Time Religion" and "Shall We Gather at the River."

He also describes the inability to keep doors locked:

There was no way to keep a door locked on the inside of the house. Many times we locked bedroom doors and the attic door, only to get up the next morning to find them unlocked and opened. On one occasion, we even locked the attic door and stuffed the key hole with pad cotton. The next morning it was wide open.

Mr. Tawes goes on to share what happened when a friend visited and was testing the ghost:

He proceeds to lock the attic door and stuff the keyhole with pad cotton. He then locked us in my bedroom, with pad cotton packed in that keyhole. He also took chairs, placed them under the door knob and wedged the feet against the floor. We then lay down to wait. I was busy telling scary stories, trying to scare him, when all of the sudden, there was a very loud crash. My friend bolted right up in bed. I said, "Here comes Ananias." He was about to say something when suddenly the chair underneath the bedroom door knob came sailing across the bedroom floor, striking the foot of the bed. Then the bedroom door flew open with a bang. There was no on there.

When he was about fifteen years old, Mr. Tawes's stepfather moved into the house and had a bad nightmare. None of the family had told him about a ghost. According to Mr. Tawes's stepfather, he was awakened by a noise. When he looked up, he noticed a

man sitting at the end of his bed. The man looked fairly old and had a handlebar mustache, a derby hat and an old-fashioned suit. His legs were crossed, and he was swaying back and forth on the cedar chest at the foot of the bed, as if it were a rocking chair. Mr. Tawes's stepfather shook his head and looked again. The man was still there. He closed his eyes for a time and then opened them again; still, the man was there. Then Mr. Tawes's stepfather grew scared and pulled the covers over his head for a few minutes. When he looked again, the man was still there, just sitting and rocking. The man vanished only when Mr. Tawes's stepfather's feet hit the floor as he bolted in fear from the room.

A few years later, the roof developed a leak after being struck by lightning. Carpenters had to open a closed-off section of the attic to work on the roof. Behind the closed-off section was a big black coffin lined with mohair. The family left it there when they moved.

HOLLAND'S ISLAND
A GHOST ISLAND

Dorchester and Somerset Counties

In 1912, there were about three hundred people living on Holland's Island, a small island in the Chesapeake Bay about fifteen miles northwest of Crisfield. There were about sixty homes, four stores, a church, a two-room schoolhouse and a post office. The island had a well-known oyster fleet that consisted of remarkably crafted vessels. The land was relatively high in relation to the other Chesapeake offshore islands. Island life was hard. Most residents made their living off the water, and families sustained themselves on home-grown food, seafood and cattle they raised on the island. In 1889, the tides shifted, and the Susquehanna River swept an enormous amount of water into the bay. Thus began a twenty-year erosion pattern that wiped out Holland's Island. A severe storm wrecked the island in 1912, and inhabitants began moving off the island to the mainland in Somerset and Dorchester Counties in large numbers. Many of the homes were lifted off their foundations and transported by barge to Crisfield, Cambridge and other towns. The church was moved to Fairmount in Somerset County and served as a meetinghouse.

By 1918, the year of the influenza, the exodus got worse, and there weren't enough people on the island to sustain the store or school. Homes were vanishing, succumbing to the encroaching sea. By 1922, all inhabitants had left Holland's Island, and only the

The Captain Ira Todd House, built on Holland's Island and then moved to Crisfield in 1912.

home of W. Grant Parks remained standing. It later became a gun club. The remainder of the island was marshland. Lorie C. Quinn Jr. wrote of the island in 1922, when the last islander left:

> *The paradise of the Chesapeake is no more. Today at low tide only vestiges are seen and at high tide the island is completely under water. Gone are the homes of the people. The dead remained faithful to the island of their lives and as the storms drove the tides to their work of destruction they slept on. The trees fell and were washed away; the banks crumbled and were buried beneath the waters; but "God's Acre" [the cemetery] stood, and as the surrounding land disappeared, with the stones still standing, this holy ground slipped, too, beneath the waters. Journey today over the site of this once prosperous and beautiful spot and as the tides reach their low ebb the searcher will see the stones of their buried dead rise above the waters, a monument to this lost island of the Chesapeake.*

The Captain Ira Todd House was moved off Holland's Island and brought to Crisfield. It sits today on the main Crisfield highway, next to another Holland's Island home brought by barge. The Todds lived in the home for a while in Crisfield and then Captain Todd died suddenly. Later, Mrs. Todd died in the home, as did a twelve-year-old child.

The Freemans, who currently own the home, have lived there since 1987 and admit that there were disturbing occurrences in the house for years after they moved in. Cynthia Freeman said in an interview that once they mentioned these events to some close friends it became apparent that some of the previous owners of the Todd home had similar experiences. One neighbor told Cynthia that everyone who lived in the house had bad experiences or sad things happen to them. Cynthia said that they had items flying off shelves, pillows being thrown on the floor, bedclothes ripped off in the night and sounds of whispers, "like someone whispering into your ear." Even teenage guests having a sleepover at the Freemans' experienced frightening things and, to this day, will not enter the house. When the Freemans moved into the house, the attic was entirely full of Todd family mementos: Bibles, photographs, church records and more. Cynthia boxed them up and returned them to members of the Todd family who lived in Crisfield. Then she had her priest, Father Aigner, say Mass at the house and give it a blessing. Since then there has been no more ghostly activity.

Today, Holland's Island is a ghost island. The old Ward House is still standing, though the water encroaches and flows beneath the floorboards at high tide. The Holland's Island Preservation Foundation, led by Stephen White, continues with efforts to prevent the extinction of the island and its memories, so that an island that was once vibrant with community life and Eastern Shore family legacies will not be lost or forgotten.

LIVING IN THE VANCE MILES HOUSE

Marion Station, Somerset County

To us, our house was not insentient matter—it had a heart, and a soul, and eyes to see us with; and approvals, and solicitudes, and deep sympathies; it was of us, and we were in the peace of its benediction. We never came home from an absence that its face did not light up and speak out its eloquent welcome—and we could not enter it unmoved.
—Mark Twain, 1896

April 26, 2002, was my forty-third birthday. It was also the first day I lived in the Vance Miles House in Marion Station, Somerset County. Having lived in Howard County most of my adult life, and in the corridor between Baltimore and Washington all of my life, making my home in Marion Station was quite a shock. We had a waterfront summer home in Somerset County before we bought the Vance Miles House, but a weekend home in the country doesn't provide the real-life experience of daily living seventeen miles from the nearest Wal-Mart, which was where people in Marion Station bought almost everything. I cried for six months.

My one comfort was the house itself. Built in 1892 by the Miles family, this Queen Anne–Victorian home had only three owners in its previous 110 years, and two of those families occupied the house

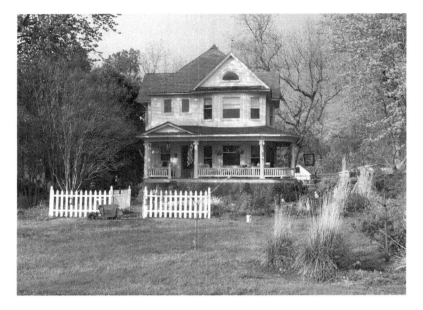

Vance Miles House, circa 1892, Marion Station, home of the author.

for nearly 50 years each. The house had been well maintained and updated, but little had changed from the original footprint of the 1890s. Marion Station grew up around the railroad in order to move produce via rail to markets north in Philadelphia and Wilmington. This region was the largest strawberry-producing region in the world at one time. Farming and seafood created the wealth that built Marion Station, and my home is located on a street formerly named "Millionaire's Row," referring to the string of large Victorian homes built at the turn of the century by the strawberry and seafood barons of the day. One of those elite was Vance Miles.

I knew little about the history of the house when we moved in, but shortly after our entry as new owners, strange things began to happen. They developed into frightening events that nearly drove us nonbelievers right out of the house. There were always strange noises—banging and clanging. We dismissed these. My college-

aged daughter was staying with us on the weekends; she heard the noises as well and was uncomfortable in the house. She has always been uneasy here. One evening, I was watching television on the first floor with my daughter. My husband was asleep upstairs. I heard a crash from the upstairs room. It sounded like a bookcase falling over. I thought my husband might have knocked something down. He descended the stairs and said, "What was that?" We investigated the upstairs rooms. The only thing we found was an open window and an eight-by-ten picture frame toppled over due to the wind. None of us would have opened that window, as there was no screen for it—mosquitoes and flies here are deadly.

Another incident occurred when we purchased our washer and dryer. We had to carry them into the basement from an outside entrance. When we were bringing the dryer in, we had difficulty getting it through a narrow passage. My husband, Dan, was on the front end of the dryer and I was on the rear, nearest the outside entrance. While balancing the heavy appliance, we heard the front door open and close. Then we heard someone walking across the living and dining room floors. We thought this strange because no one had come down the driveway (which was just outside the basement entrance). I set the dryer down and looked out the basement door. No car. The dog didn't bark. We knew that whoever came in had walked up to the door. I sent Dan with our dog to check the upper floors of the house. He checked every room, including the attic. He found no trace of anyone.

A few months later, someone came down our driveway with North Carolina tags and said that he was researching his genealogy. As he got out of his car, he walked over to us, explaining that Vance Miles had built this house and he (the visitor) was related to Vance's wife, Lillian Haynes. Then he said, "Vance Miles committed suicide right in your living room!" This man's visit was startling because he had so much information about our home and the Miles family. One of his contacts gave us a photo of Vance, with his family, sitting on our front porch in 1924. Later,

the visitor returned and explained that Vance had not, in fact, ended his life in the house but while fishing in Colbourne Creek, which is nearby.

Then the strange occurrences got ugly. I was having difficulty sleeping. I would be in that twilight stage, halfway between consciousness and sleep, and would see a dark figure hovering above my bed. Sometimes it would choke me. It was awful and terrifying, and I feared going to sleep.

My husband was walking through our dining room when he noticed the chandelier begin to sway. It built momentum and went faster. Just as he was reaching to stop it, one of the antique globes from the chandelier dropped and crashed into two dozen Valentine's Day roses he had bought for me. The globe broke, and it toppled the large vase on the table. There was also this feeling that both of us had, as if we were being watched. Dan could occasionally see the figure—head and shoulders—of a man with his peripheral vision, but when he would turn to look directly at the apparition, it would vanish.

I began to get more nervous and asked several people advice on what to do. Few were helpful. Every time I described what was happening, I felt foolish. Then our bathroom mirror fell out of its casing over the sink and shattered into thousands of sharp shards. Both of us cut ourselves cleaning up the mess. My son and daughter-in-law claimed that they hated staying in the back bedroom when they visited. It was creepy—a bad feeling, they said. Then the second mirror we installed in the bathroom—this time in a different location—fell off the nail and shattered.

The event that pushed me over the edge had to do with an antique plate a friend had given me. It was a 1918 calendar plate with the bluebird pattern made by Homer Laughlin. I had it on my sideboard in the dining room, next to a small plate given to me by my aunt. As I was walking into the dining room from the kitchen, I saw the bluebird calendar plate flip off the sideboard and break in two. There was no cause—no bump and no

vibration. I stood there for a few minutes asking myself if I really saw what I thought I saw. I decided to protect the other small plate next to the one that had just broken. I put it into my locked china closet. I retrieved the key, unlocked the cabinet, placed the small plate inside, locked the cabinet, tested the lock and placed the key back in the drawer. I went to bed. That night I thought about what it would take to move out, even though we had only been living there for a little over a year at the time. The next morning, I began to tell my husband about the plate incident. He said, "You should be more careful with the china closet. You didn't secure the lock. When I came down this morning, the glass

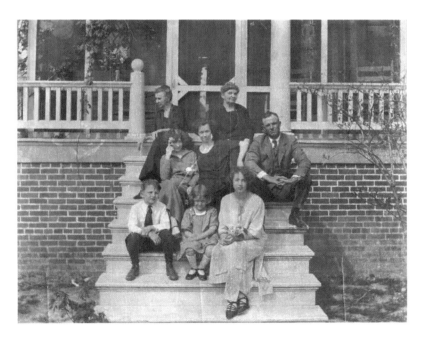

The Vance Miles family in front of their Marion Station home, 1924.
Clockwise from top right: Christine Roach Miles (mother of Vance Miles), Vance Miles, Gladys Miles (daughter of Vance), Margaret Miles (daughter of Vance), Ben Stevenson (nephew of Vance), Gertrude Stevenson (niece of Vance), Nannie Haynes (mother-in-law of Vance) and Lillian Miles in center (wife of Vance Miles).

door was wide open." At that moment I decided to put the house up for sale.

The minute I put the house up for sale, all weird occurrences stopped—at least for Dan and me. One interested couple who came to see the house asked if they could have one more look at the floored attic. We were downstairs by then, and I allowed them to go upstairs to the attic while we waited on the first floor. When they came down, the woman asked if the man upstairs was my father. I explained that my father had passed years ago. She described the man to us: tall, lean, in his sixties or seventies, gray hair, black work pants, white undershirt. The description was general and could have fit any number of people. But what she saw was not a person.

While I was relieved that the paranormal activity had stopped, I wasn't sure why it stopped. I had the opportunity to consult a psychic, whose insight to me was: "whatever it is, it doesn't want you to go." I blessed the house with holy water that I brought back from the Shrine of Our Lady of Knock in Ireland. I took the house off the market. We have lived in peace ever since. Others have seen and experienced strange, often eerie things, but not us. Whatever, or whoever, this presence was, it is content with the living arrangements in the house…and so are we.

SELECTED BIBLIOGRAPHY

BOOKS

Carey, George. *Faraway Time and Place*. Washington, D.C.: Robert B. Luce, Inc., 1971.

—————. *Maryland Folk Legends and Folk Songs*. Cambridge, MD: Tidewater Publishers, 1971.

Chappelle, Helen. *The Chesapeake Book of the Dead*. Baltimore, MD: Johns Hopkins University Press, 1999.

Darling, William. *The Murder of Sallie E. Dean*. Denton, MD: Baker Printing Company, 1971.

Earle, Swepson. *The Chesapeake Country*. New York: Weathervane Books, 1923.

—————. *Maryland's Colonial Eastern Shore*. New York: Weathervane Books, 1916.

Fisher, William Harmanus. *Some Old Houses of Maryland*. Oxford, MD: Mrs. William H. Fisher, 1979.

Fleetwood, Mary Anne. *Voices from the Land*. Caroline Historical Society, 1983.

Flowers, Thomas. *Shore Folklore*. Cambridge, MD: Thomas Flowers, 1989.

Footner, Hulbert. *Rivers of the Eastern Shore.* N.p.: Holt, Rinehart and Winston, 1944.

Forman, H. Chandlee. *Early Manor and Plantation Houses of Maryland.* Easton, MD: Waverly Press, 1934.

————. *Old Buildings, Gardens and Furniture in Tidewater Maryland.* Cambridge, MD: Tidewater Publishers, 1967.

Gallagher, Trish. *Ghosts and Haunted Houses of Maryland.* Cambridge, MD: Tidewater Publishers, 1988.

Giles, Ted. *Patty Cannon, Woman of Mystery.* Easton, MD: Easton Publishing Company, 1965.

Hammond, John Martin. *Colonial Mansions of Maryland and Delaware.* Philadelphia: J.B. Lippincott, 1914.

Hays, Anne, and Harriet Hazleton. *Chesapeake Kaleidoscope.* Cambridge, MD: Tidewater Publishers, 1975.

Ingram, Prentis. *Land of Legendary Lore.* Easton, MD: Gazette Publishing House, 1898.

Lake, Matt. *Weird Maryland.* New York: Sterling Publishing Company, 2006.

McCall, Davy. *Tricentennial History of St. Paul's Church, Kent.* Chestertown, MD: The Church, 1993.

Mullikin, James. *Ghost Towns of Talbot County.* Easton, MD: Easton Publishing Company, 1961.

O'Conor, Herbert R. *Maryland: A Guide to the Old Line State.* New York: Oxford University Press, 1940.

Okonowicz, Ed. *Welcome Inn.* Elkton, MD: Myst and Lace Publishers, 1995.

Peterman, Reverend Thomas. *Bohemia 1704–2004.* Devon, PA: William T. Cooke Publishing, 2004.

Preston, Dickson. *Trappe: Story of a Small Town.* Trappe Bicentennial Committee and Trappe Town Council, 1976.

Roth, Hal. *Conversations in a Country Store.* Vienna, MD: Nanticoke Books, 1998.

————. *Patty Cannon. The Monster's Handsome Face.* Vienna, MD: Nanticoke Books, 1998.

Scarborough, Katherine. *Homes of the Cavaliers.* New York: MacMillan Company, 1930.

Shannahan, J.H.K. *Tales of Old Maryland.* Bowie, MD: Heritage Books, 1907, 2001.

Shomette, Donald. *Pirates of the Chesapeake.* Cambridge, MD: Tidewater Publishers, 1985.

Tilghman, Oswald. *History of Talbot County Maryland 1661–1861.* 1915. Reprint Salem, MA: Higginson Book Company, 1995.

Touart, Paul B. *Along the Seaboard Side.* Worcester County Commissioners, 1994.

———. *Somerset, An Architectural History.* Annapolis, MD: Maryland Historical Trust, 1990.

Townsend, George Alfred. *Tales of the Chesapeake.* Cambridge, MD: Tidewater Publishers, 1968.

Truit, Dr. Reginald, and Dr. Maillard G. Les Carlette. *Worcester County, Maryland's Arcadia.* Snow Hill, MD: Worcester County Historical Society, 1977.

Usilton, Fred. *History of Kent County Maryland.* N.p.: Janaway Publishing, 1911, 2003.

Weeks, Christopher. *Between the Nanticoke and the Choptank.* Baltimore, MD: Johns Hopkins University Press, 1984.

———. *Where Land and Water Intertwine.* Baltimore, MD: Johns Hopkins University Press, 1984.

Wilson, Woodrow T. *Crisfield Maryland 1676 to 1976.* Baltimore, MD: Gateway Press, 1977.

ARTICLES AND DOCUMENTS

Baltimore News. "Sheppard Hanged in View of Public." August 27, 1915.

Baltimore Sun. "Wish Sheppard Hanged." August 28, 1915.

Denton Journal. "Price Makes a Full Confession." May 11, 1895.

Folklore Collection. Files on Ghosts, Hauntings and Legends. Nabb Research Center, Salisbury University.

Historical Society of Cecil County. "Original Account of Elkton Fifty Years Ago." In *Elkton in the 1830s*. Elkton, MD: Cecil Whig Publishing Co. and Elkton Chamber of Commerce, July 1974.

Huddleston, Mary. "Reliance: Life after Patty Cannon." *Caroline Times-Record* 7, no. 31 (February 28, 1990).

Hulseman, George. "Eerie Events Recall Murder." *Star Democrat*, June 26, 1989.

Kaehn, Mary Jane. "Bloomingdale." *Kent Shoreman* 7, no. 8 (January 1973).

Miller, M. Sammy. "Patty Cannon: Murderer and Kidnapper of Free Blacks: A Review of Evidence." *Maryland Historical Magazine* 72, no. 3 (Fall 1977).

Roth, Hal. "Patty Cannon and the History Detectives." *Tidewater Times*, November 2003.

Stump, Brice. "The Legend of Green Briar Swamp...Myth or Reality?" *Dorchester News*, November 30, 1966.

ABOUT THE AUTHOR

Mindie Burgoyne, a native Marylander, lived most of her life between Baltimore and Washington, D.C., but moved to Maryland's rural Eastern Shore seven years ago. Currently, Mindie works full time for the Maryland Department of Business and Economic Development, serving businesses and local governments on the Eastern Shore. Mindie and her husband, Dan, have six grown children and seven grandchildren. They live in Marion Station at the southernmost tip of Maryland in an old Victorian house with their three large dogs.

Visit us at
www.historypress.net